NOTABLE
NATIVE PEOPLE

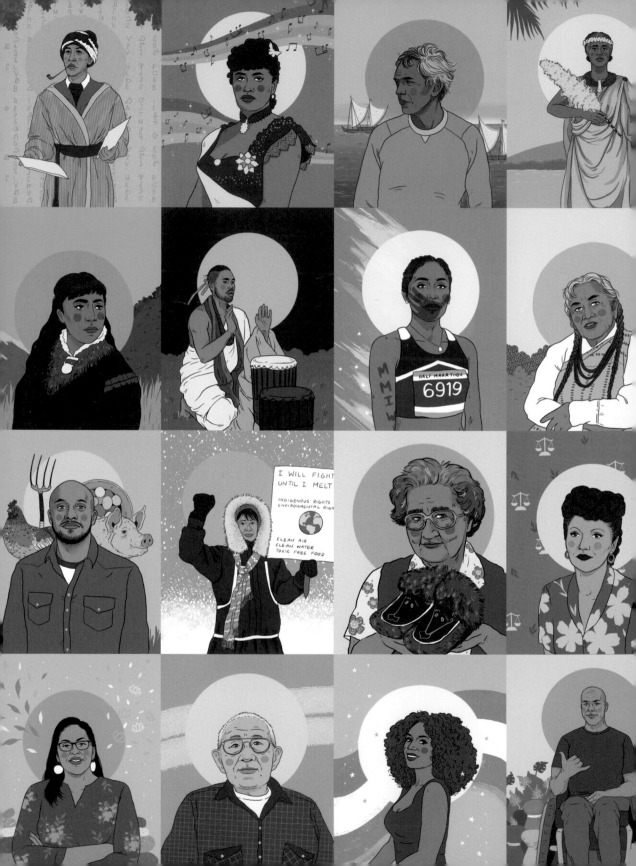

NOTABLE NATIVE PEOPLE

50 Indigenous Leaders, Dreamers, AND *Changemakers* FROM *Past* AND *Present*

ADRIENNE KEENE

ILLUSTRATIONS BY CIARA SANA

TEN SPEED PRESS
California | New York

To Nell, my usdi tuya

CONTENTS

INTO AN INDIGENOUS FUTURE

The United States as we know it has not always existed—there is a deep and rich legacy of people inhabiting these lands long before the first European colonists arrived and altered the course of history. The lands in what is currently known as the United States encompass the homelands of 574 federally recognized American Indian tribal nations, as well as hundreds more state-recognized and non-recognized tribal nations. In addition, through later acts of land seizing—and in the case of the Hawaiian Kingdom, illegal overthrow—our extended Indigenous community also includes Kānaka Maoli and Alaska Native people. These three groups encompass vast diversity—innumerable cultural groups, nations, languages, histories, experiences, struggles, and joys.

Indigenous people are the first people of the lands around the world. To be Indigenous is to be of a place, to have creation stories of how your people emerged from the land, and to be connected to a community from that place. As the first people of their respective lands, American Indian people, Alaska Native people, and Kānaka Maoli have expertly stewarded and cared for the land, built vast cities and societies, utilized democratic governance, and carried and shaped cultural practices and traditions for centuries. But because of the destructive legacy of settler colonialism, most Americans know very little about Native people beyond the stereotypes of Hollywood Indians, igloos, or Hawaiian grass skirts, but our reality is much different. We have—and have always had—leaders across all sectors, from science, art, and activism to education, fashion, politics, and beyond.

I am a Native person who was raised far away from her Cherokee community, surrounded by non-Natives, and educated in predominantly white schools. Growing

up, the lesson I learned in school about Indigenous people was that we were people who existed only in the historic past, that we and our cultures were extinct and had no connection to the present day. I never learned about any Native people other than historic male leaders like Sitting Bull and Geronimo, and I was surrounded by images in popular culture of harmful stereotypes. But this narrative of Native people couldn't be more wrong. We are not extinct, and there are so many important Native people of the past and today whose stories and lives have resonance, power, and are worth learning about. Now, as a scholar who studies, writes, and teaches about the importance of representation, I know the power of sharing stories that push beyond stereotypes and move Indigenous people from the historic past into the modern present and the future.

Not only are most of the images and stories we hear about Native people stereotypical, Indigenous people are also largely invisible in American culture. This invisibility is reflected in Hollywood, the media, education, statistics—everywhere—and it didn't just happen: it's a direct result of the ongoing genocidal policies and practices of colonization. But the Indigenous world I know is dramatically different. When I open my social media feeds each day, I see a world full to the brim of Indigenous joy, vibrant cultural revitalization, Native babies speaking their languages, Native fashion shows, Indigenous futurisms, awe-inspiring beadworkers, hilarious Indigenous memes, resilience, and brilliant community-focused work. In my life, work, and writing, I want to showcase a bit of that Indigenous brilliance and joy, because it gives me so much hope.

Being in this community has also introduced me to amazing Indigenous people I would never have encountered otherwise. *Indigenous Goddess Gang*, an online community and magazine started by Kim Smith, who is Diné, has a "Matriarch Monday" feature, where they post a different Native woman from history each week—it is how I first learned about several of the women in this book. Every Monday, I am so excited to see a Native person represented in a position or point in history that I had never known about. American history has purposely written Natives out of the national narrative, because our continued existence serves as a reminder that this country exists on stolen lands and was built by attempting to destroy millions of Indigenous people. Therefore, the work of uncovering the stories of Native people unknown to most of the public is important decolonial work, and there's still so much for us all to learn.

Because there was no way that just the fifty people in this book could equitably represent the full spectrum of such beautifully diverse Indigenous people, I strived to curate a balanced group. The people in this book represent a small slice of the Native experience, balanced across the three broad cultural groups of American Indian, Alaska Native, and Kānaka Maoli, as well as various gender identities, ages, locations, tribal affiliations, and work. I also intentionally focused on the inclusion of Black Native, female, LGBTQ+ and Two Spirit people. In the spirit of Indigenous relationships, I created the list of people in this book collaboratively and vetted the final group with community

members and friends to ensure it maintained this spirit of inclusion. All of that said, this is in no way even close to representative of the incredible stories and perspectives of all Indigenous people. I hope this book inspires you to seek out more stories, listen to Native voices, and learn from the first people of this land.

Our world is in a time of dramatic change. Political unrest and climate change have caused an increasingly uncertain future. Our people lived on this land for millennia prior to colonization, and I believe that Indigenous knowledge holds the key to the future. We have survived genocide, and our communities continue to advance, grow, develop, and change while maintaining our cultural roots. Given the opportunity, I know that our experiences and knowledge could turn things around. In order to embrace this Indigenous future, we need to learn from our present and our past. A common refrain about Indigenous representation is "we are still here," which is a powerful reminder that in spite of everything, we haven't been erased. I hope that this book and the stories of these incredible individuals can help us to see that not only are we still here, we have always been here, and always will be.

A NOTE ON TRIBAL NAMES: Tribal names can be a bit tricky—there are official federally recognized names and more colloquial versions of those names, widely used (but not preferred) names given by settlers, as well as Native language names and other names that may be preferred by tribal members. Many of the names you may be familiar with, such as Sioux (for Lakota, Dakota, and Nakota) or Winnebago (for Ho-Chunk), were names given by settlers and do not come from Native languages, so many of these names are not preferred or are falling out of favor. Some settler-given names, however, like Osage, are considered acceptable and widely used. When noting the tribe(s) to which they belong, Native people may also choose to include (or not include) their specific band or clan affiliation(s). In this book, for the sake of simplicity and to the best of my knowledge, I have used the tribal names most commonly used and accepted by members of those tribes, as well as the tribal names preferred by the people in this book.

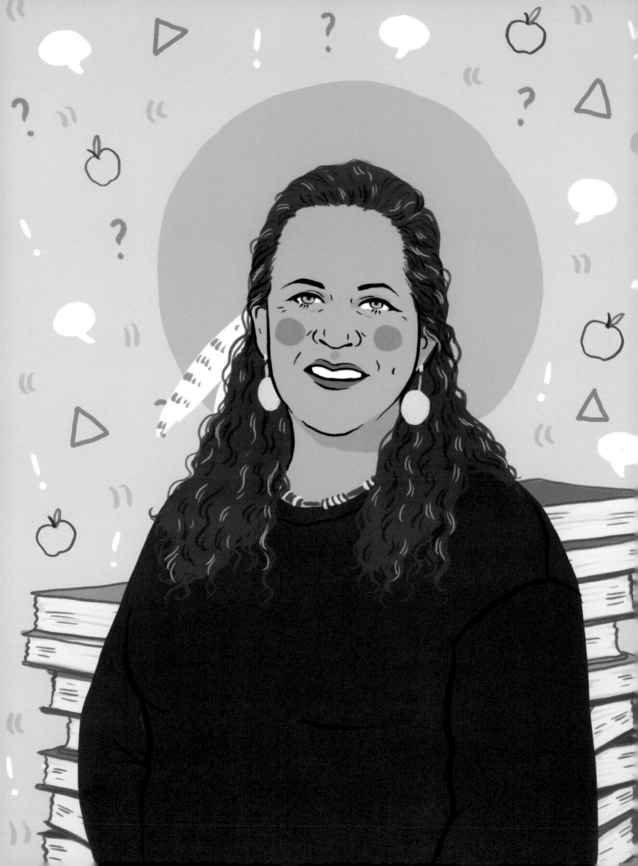

JESSIE LITTLE DOE BAIRD

Mashpee Wampanoag

1963– • LINGUIST AND LANGUAGE REVITALIZATION ADVOCATE

When jessie little doe baird was a young woman, she began having dreams of her ancestors speaking to her in a language she couldn't understand. jessie is a citizen of the Mashpee Wampanoag nation, which is the nation that met the *Mayflower* in 1620, when it landed on the shores of their homelands in present day Massachusetts. When jessie was born in 1963, Wôpanâak, the Wampanoag language, had not been spoken for 150 years. But her dreams of a language spoken by her ancestors were the first step on a journey to reclaim her people's language and bring it back to life.

When she began her language work in the early 1990s, jessie was a mother of five and a social worker living in her homelands on Cape Cod in Massachusetts. She had no prior linguistic training, but she felt strongly that the work needed to be done by a Wampanoag person. Working with renowned linguist Kenneth Hale at the Massachusetts Institute of Technology (MIT), jessie painstakingly reconstructed spoken Wôpanâak. They used thousands of historic documents written in Wôpanâak, including the first Bible printed in North America, and paired them with pronunciations and grammatical tools from other related Native languages. After graduating with a master's degree in linguistics in 2000, she launched the Wampanoag dictionary project, solidified Wôpanâak grammar, and began teaching the language to members of her Mashpee Wampanoag community. In doing so, she ignited a language renaissance for her entire nation.

In 2010, she was awarded a MacArthur Foundation Fellowship (often referred to as the "Genius Grant") for her work, and now, decades after her first dream, a growing group of children speak the language of their ancestors at Weetumuw Katnuhtôhtâkamuq (The Weetumuw School), a Wôpanâak language immersion school. In a magazine interview, jessie said, "Learning our language gives us a basis for why we view the world the way we do. . . . Wampanoag is something that no one can take from us."

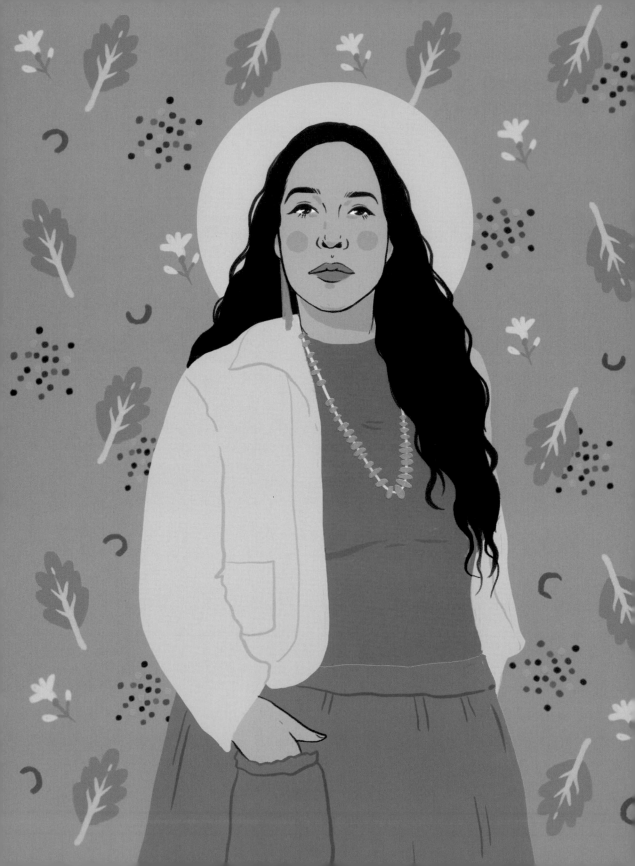

ROWEN WHITE

Akwesasne Mohawk

1979– • SEED KEEPER

Rowen White is a seed keeper from the Mohawk community of Akwesasne. She has been a passionate activist for seed sovereignty—the right of communities to control and protect their own seeds—since 1997, when she was a student at Hampshire College, which has a working farm. It was there that she realized that "seeds have stories," and when she began to see seeds as relatives and connections to our ancestors. Seed keeping is the ancient practice of saving seeds from plants for future use, and it is especially meaningful for many Indigenous people for sovereign and spiritual reasons. Many crops that Native people carefully cultivated and relied upon for centuries were lost or nearly lost during colonization, when settlers purposefully destroyed Indigenous food systems. Seed keepers and advocates like Rowen work to save, catalog, distribute, and educate about Native seeds, and as a result, Indigenous crops are now thriving in backyards, farms, and homelands throughout the world. Local cooperatives like the Sierra Seeds collective in Northern California, which Rowen co-founded in the early 2000s, work to educate and continue seed production. Rowen offers seed trainings around the country as the project coordinator for the Indigenous Seed Keepers Network.

Indigenous foods have the power to improve Native people's health and can increase our connections to land, cultural knowledge, and ancestors. The work of seed keepers like Rowen is making sure that seed keeping practices that have survived for thousands of years carry forward into the future. As Rowen writes of our seed relatives: "Following this diverse trail of seed and stories, I have come to understand more about myself, my ancestral roots, and have received the blessing to carry and keep dozens of unique heritage seeds in our baskets and bundles for our family to be nourished and to pass along to future generations. I have come here to deeply listen to what the seeds have to share."

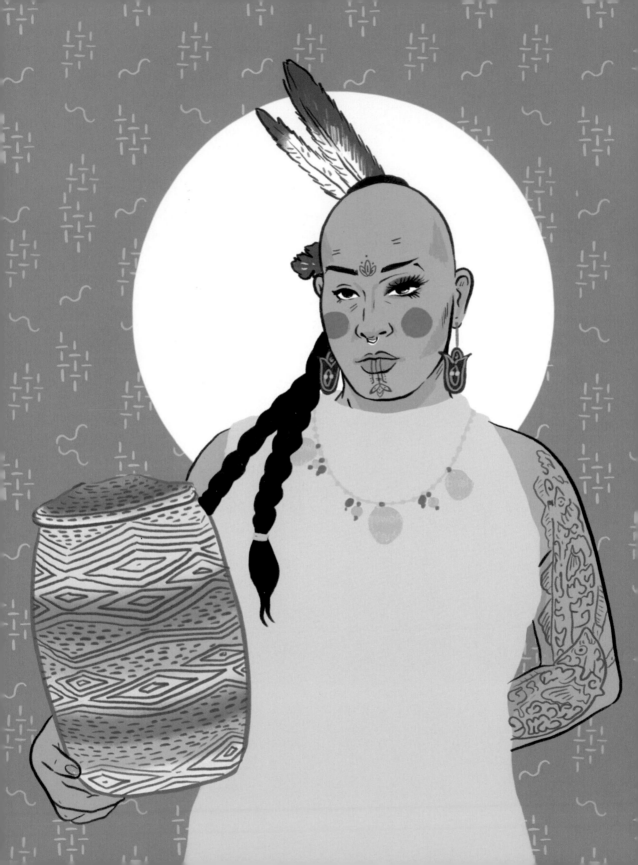

GEO SOCTOMAH NEPTUNE

Passamaquoddy

1988– • BASKETMAKER, DRAG ARTIST, AND CULTURE KEEPER

Geo Neptune is a model, drag performer, language revitalization worker, youth mentor, storyteller, activist, and master basket artist. They identify as nonbinary and Two Spirit, a term born in Native American LGBTQ+ spaces in the 1990s. Two Spirit is an umbrella concept for a multitude of tribally specific gender identities and roles that have existed in Native communities since before colonization. Colonization brought patriarchy to most Native communities, and it sought to push out any gender identities that did not conform to the rigid binary of male and female.

Born in Indian Township, Maine, Geo was taught how to weave baskets at the age of four by their grandmother Molly Neptune, a master basket artist. Geo had a natural gift for the art form and quickly became a master artist themselves, beginning to teach classes at age eleven and becoming the youngest person to receive the title of Master Basketmaker from the Maine Indian Basketmakers Alliance at twenty years old.

Geo attended college at Dartmouth, which is where they tried drag for the first time. They dreamed of becoming an actor in New York after graduation but felt the pull to return home to their community in Maine, where they continued to hone their basketry skills and began working with youth. Today, Geo's baskets—which incorporate aspects of their identity and family history—are highly sought after works of art, and their videos of drag transformations are viewed by thousands on TikTok and Instagram. They see their work in basketry and drag as two parts of their Native identity, saying, "I hope that others can see that my basketmaking is an important part of cultural preservation as well as evolution, that my drag is a challenge to Western patriarchal societal norms, and that these two things are not separate, because these art forms are who I am as a Two Spirit."

Geo is also passionate about traditional tattooing practices and the revival of their community's tattoos. Traditional tattoos are considered sacred and ceremonial and were generally received as markers for important life milestones. Many communities lost their traditional tattooing arts due to colonization. Working with Indigenous friends and artists who have tattoo ceremonies of their own, Geo creates intricate hand-poked designs, imbued with story and meaning for the recipient.

In 2020, Geo ran for the school board in their home community of Indian Township and won, becoming the first openly Two Spirit person to be elected to office in the history of the town. Geo continues to live on their homelands and work with community youth programs, teaching the Passamaquoddy language, traditional arts, and drag to youth in the lands that are currently known as Maine.

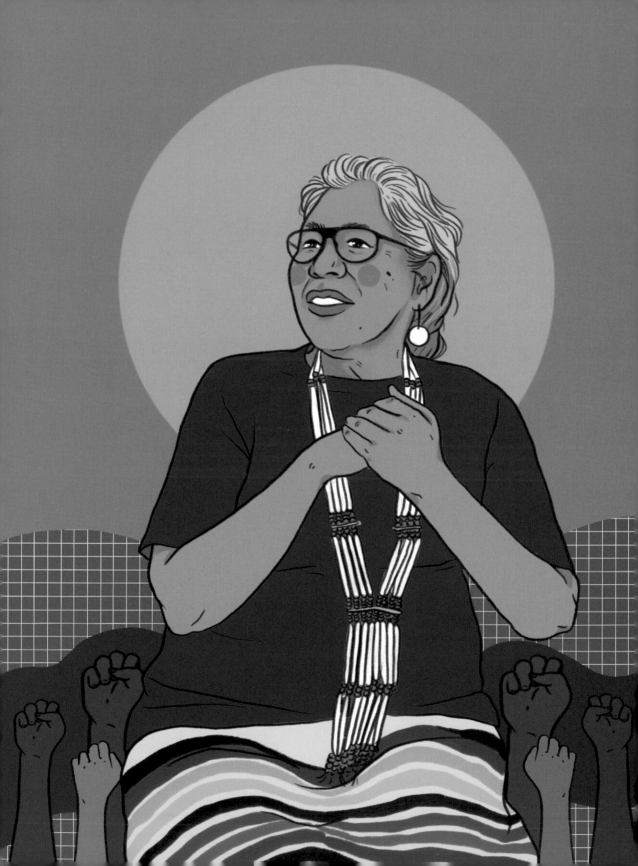

MADONNA THUNDER HAWK

Cheyenne River Lakota

1940– • EDUCATOR, ORGANIZER, AND ACTIVIST

A grassroots organizer, educator, and advocate for generations, the impact of Madonna Thunder Hawk's activism has been felt on the community, national, and international level. Born on the Yankton Sioux Reservation, she has advocated for Native rights and education and has founded spaces that prioritize Native women. Madonna was part of the federal relocation program in the 1960s that brought her to San Francisco. It was there that she became involved with the 1969–1971 occupation of Alcatraz Island and went on to be involved in every modern Native occupation since then, including Wounded Knee in 1973 and Standing Rock in 2016.

Along with her deep involvement with the American Indian Movement (AIM) in the 1970s, Madonna, her friend and co-organizer Lorelai DeCora Means, and other Indigenous women founded Women of All Red Nations (WARN) in 1978 with the mission of community organizing around issues related to "colonialism, land struggles, energy resource protection, and Indigenous rights recognition." WARN was a call for Indigenous women to recognize their responsibilities and power as protectors of community both locally and globally. Unhappy with the white, Western school system that didn't serve Indigenous students well, Madonna and Lorelai also established the We Will Remember Survival School in 1974. The goal of the school was to serve American Indian students who had been pushed out of traditional schools, whose parents may have been incarcerated or who otherwise weren't being supported in public school systems. The curriculum and environment centered on Native identity, cultures, and sovereignty; Madonna's daughter, Marcella, was a graduate of the school. Madonna's activism has stretched beyond U.S. borders, as she has advocated for Native rights and sovereignty abroad and at United Nations conferences.

In 2004, she established the Wasagiya Najin (Standing Strong) Grandmothers' Group on the Cheyenne River Reservation, working to rebuild kinship networks, support Cheyenne River's efforts to stop the removal of their children, and to create local resources on which the Nation can rely. She also serves on the matriarch's council of the Warrior Women Project. She does this work to serve her community, knowing that grassroots organizing is not an easy path. She says, "I don't see so many community organizers. I don't see too many of that type of thing going on, because there is no pension for radicals. You don't expect anything, you just do it."

JOSHUA LANAKILAOKA'ĀINAIKAPONO MANGAUIL

Kanaka Maoli

1986– • ACTIVIST, CULTURE KEEPER, AND MAUNA KEA KIA'I (PROTECTOR)

The Kanaka Maoli resistance camp against the Thirty Meter Telescope (TMT) on Mauna Kea, Pu'uhonua o Pu'uhuluhulu, was established in July 2019. Joshua Lanakilaoka'āinaikapono Mangauil, or Lanakila, was one of the leaders of the camp's daily cultural protocol, performing ceremonies as well as teaching hula and chants so others in the camp could participate. In his hula lessons, he shared Indigenous stories and knowledge as well as dance steps, teaching about the cycles of water, the moon, and the tides. A culture bearer and advocate for the rights of Native Hawaiians, Lanakila has been working to protect Mauna Kea since the earliest days of the fight. In 2014, at a groundbreaking ceremony for the TMT, Lanakila scaled the mountain alone, on foot, to emerge behind the camera crews and delay the ceremony long enough for reinforcements to arrive. Since then, he's been a leader in the resistance movement.

Born and raised in Hāmākua on the Big Island of Hawai'i, Lanakila attended a Native Hawaiian language immersion school, Kanu o ka 'Āina, where he became fluent in 'Ōlelo Hawai'i (Hawaiian language) and immersed in cultural practices. After graduation, he became a Hawaiian Studies teacher in local public schools, after-school programs, community colleges, and colleges. He launched the effort to found the Hawaiian Cultural Center of Hāmākua in 2014 and serves as the executive director and head instructor.

In the fall of 2020, Lanakila ran for an island-wide elected position in the Office of Hawaiian Affairs. While his campaign was ultimately unsuccessful, he saw it as an opportunity to fulfill his kuleana (responsibility) "of continuing to unify the people of Hawai'i through cultural revival and education." He says, "Great changes are before us, and now we have the kuleana as with each generation to decide if it will be a positive and healthy shift our descendants will be proud of."

Lanakila believes strongly in protecting the land in Hawai'i because he knows that Kanaka culture is inseparable from the land. To him, the fight to protect Mauna Kea isn't just about ecological impact or Native Hawaiian "rights"—it's about cultural survival. He says, "We take care of the land because without the land, we have no culture. Our culture cannot exist without these places."

EDMONIA LEWIS

Mississauga Anishinaabe
1844–1907 • SCULPTOR

Edmonia Lewis, or Wildfire, was the first woman of African American and Native heritage to gain international recognition in the fine arts world as a sculptor. Born in 1844 to an Anishinaabe mother and a free Black father, she spent the first twelve years of her life with her mother's people in Upstate New York, selling Anishinaabe arts to tourists. When her brother moved to California to mine for gold, he sent money home to help fund her education. Through his help as well as funding from abolitionist societies, she enrolled at Oberlin College, one of the few colleges at the time who accepted women and people of color, where she began to hone her sculpting skills. While there, she was subjected to intense discrimination and racist attacks that ultimately led to her leaving the college and moving to Boston. In Boston, she got involved with abolitionist societies working to end slavery, and these societies and patrons helped to advance her work as an artist.

By selling her sculptures, she was able to fund her first trip to Europe in 1865. She visited London, Paris, and Florence, before renting a studio in Rome in 1866. She ended up staying in Europe for the majority of her adult life. In Italy, Edmonia did all of her marble sculpting herself, which was not the norm for the time. She not only lacked the funds to hire local Italian artisans but she also wanted to retain creative control and didn't want anyone to be able to question her talent or take credit for her work. Her pieces were sculpted in a classical style but often depicted Black and Native subjects. Edmonia's most famous works of Native people, *Hiawatha* and *Minnehaha,* were inspired by the poem "The Song of Hiawatha" by Henry Wadsworth Longfellow. Other subject matter she worked in included biblical scenes, commentary on the oppression of Black people, and occasional portrait busts.

Edmonia passed away in London in 1907 at the age of sixty-three. Many of her works did not survive, but those that did are held in the collections of the Smithsonian American Art Museum, the Metropolitan Museum of Art, and other major museums. Despite living most of her adult life in cities away from her homelands, she never lost her love of the land, saying, "There is nothing so beautiful as the free forest. To catch a fish when you are hungry, cut the boughs of a tree, make a fire to roast it, and eat it in the open air is the greatest of all luxuries. I would not stay a week pent up in cities, if it were not for my passion for art."

SERGIE SOVOROFF

Unangan (Aleut)

When Sergie Sovoroff was born in the small village of Nikolski on Umnak Island, far out in the Bering Sea, his people were still allowed to hunt sea otters using iqyax, or Aleut sea kayaks. Nine years later, the U.S. government outlawed sea otter hunting, and as a result, the iqyax and knowledge around them began to disappear. But Sergie had loved watching iqyax at sea, and as a young man, he began to make small wooden models of the boats, which he used throughout his life to preserve and to pass on traditional knowledge. Sergie's models are held in museum collections around the world, though sadly he is often not credited as the artist. His models frequently depict the three-hatch uluxtax, which came into existence during the time of Russia's presence in the Aleutian Islands in the 1800s and include a model of a Russian Orthodox priest being shuttled from village to village by Aleuts.

Many Americans know about the incarceration of Japanese Americans during World War II, but few know about the Aleut evacuation and incarceration—of which Sergie was a survivor. In 1943, the U.S. government forced more than eight hundred Aleut people to leave their villages over fears of Japanese invasion. The evacuees lived in internment camps throughout southeast Alaska, thousands of miles from home, for the duration of the war. These camps were often located in abandoned canneries, where conditions were grim, and it was impossible to practice traditional Aleut lifeways. Many died in the camps, and after the war, many of the villages were never reestablished. Sergie and his family eventually were able to return to Nikolski, where Sergie lived until his passing. In 1988, the U.S. Congress passed the Aleutian and Pribilof Islands Restitution Act, paying $12,000 to each surviving Aleut who had gone through internment.

Throughout his life, Sergie traveled extensively to Aleut communities, teaching about iqyax and uluxtax and inspiring younger generations. He is directly credited by many as being the reason why knowledge about iqyax was able to be revitalized in the twenty-first century. In addition to his expertise on traditional sea kayaks, Sergie was the keeper of a wealth of other Aleut cultural knowledge about plants, language, and the sea, and he worked to share this knowledge widely so that it could continue for future generations.

SETTLER COLONIALISM 101

If you live in what is currently known as the United States, you live in an active settler colonial society. What does that mean? It means that the United States was built by an outside force occupying an already occupied land and (attempting to), in the words of Australian scholar Patrick Wolfe, "destroy in order to replace." There are two main types of colonialism: external colonialism and settler colonialism.

External colonialism (that is, "y'all left but left a big mess") describes an occupying force coming into an already existing nation and taking over control of governing and resources and sending those resources back to their home country in another location for their own benefit. This is what we typically think of when we hear "colonialism" (like the stereotype of British men in safari helmets). These colonizers might eventually leave, leaving behind a post-colonial mess for Indigenous people to clean up.

Settler colonialism (that is, "y'all never left") describes an occupying force coming to a land with the intention of destroying whatever societies are already there and building a new country on top of what already exists. Examples worldwide include the United States, Australia, New Zealand, Canada, and South Africa. There is no post-colonial life for the people Indigenous to these places; colonialism is still happening.

Everything in American society—the government, national language, laws, economy, and "American culture"—is all colonization. In the words of Patrick Wolfe, settler colonialism is a "structure, not an event," meaning it's not something that "happened" a long time ago that we can move on from. It's the very structure American society is built on, and it's baked into everything Americans do. So, colonialism isn't in the past; it's current and ongoing.

The only way to end colonization is to go through a process of decolonization. Decolonization isn't about making things better for Indigenous people under the current structure; it's about returning land to Indigenous stewardship and revitalizing the knowledge associated with that land. Decolonization entails two words: Land Back. We don't have to know what this would look like to start working toward decolonization, but the first step is recognizing that we still live in a settler colonial society.

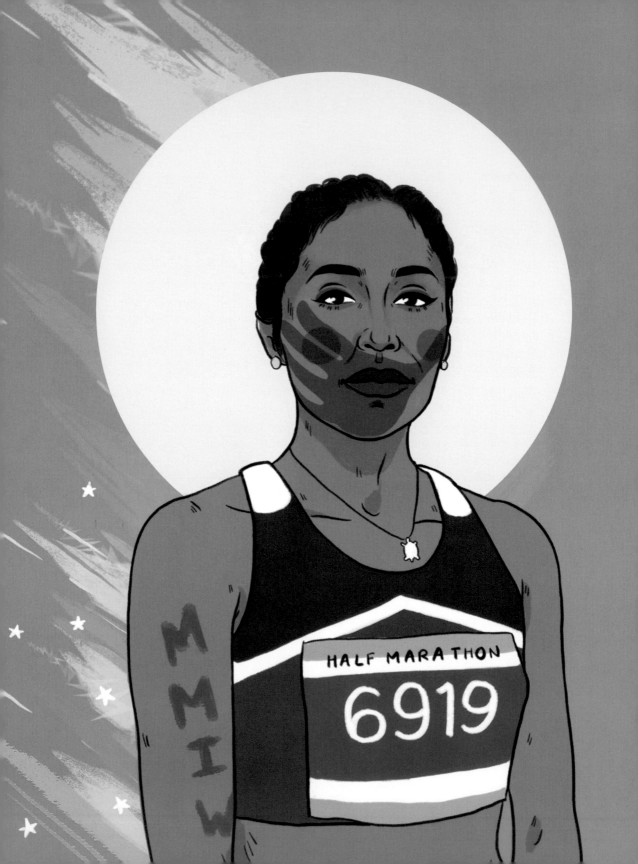

JORDAN MARIE BRINGS THREE WHITE HORSES DANIEL

Kul Wicasa Lakota

1988– • PROFESSIONAL RUNNER AND GRASSROOTS ORGANIZER

Jordan Marie Brings Three White Horses Daniel is a fourth-generation runner. She was born on her Lakota homelands in Lower Brule, South Dakota, but moved with her parents to Maine when she was nine, leaving behind her Native community and entering a world where she was seen as different. Running became her escape and her way to honor her great-grandpa, grandpa, grandma, and mother who were all accomplished competitive runners, as well as her ancestors, who utilized running as a way to carry messages among their people.

In 2019, Jordan had the opportunity to run the Boston Marathon with a Native organization called Wings of America. At that race, she decided to dedicate her run to the cause of Missing and Murdered Indigenous Women (MMIW), honoring the thousands of Indigenous women who have gone missing or who have lost their lives to violence in the United States and Canada, many of whose cases remain uninvestigated and unsolved. She painted the letters "MMIW" on her leg and arm and covered her mouth with a red handprint, which is a symbol used by activists in the MMIW movement. According to Jordan, the handprint represents "all the voices who have been silenced by the long-standing violence our women, girls, and relatives continue to experience." She also dedicated a prayer for each of the twenty-six miles to twenty-six MMIW.

As the founder of grassroots organizing collective Rising Hearts, participating in prayer runs is an important part of Jordan's activism. These runs raise awareness for specific Native causes, and the participants use the runs as a ceremonial space to pray. The runs are healing for Jordan and help her recenter her focus on her loved ones. She says, "A prayer run is surrendering yourself for something more than what you're doing, your own aspirations. You're giving up that time and space . . . for your loved ones, for your relatives, for your communities, and staying in prayer and praying for them."

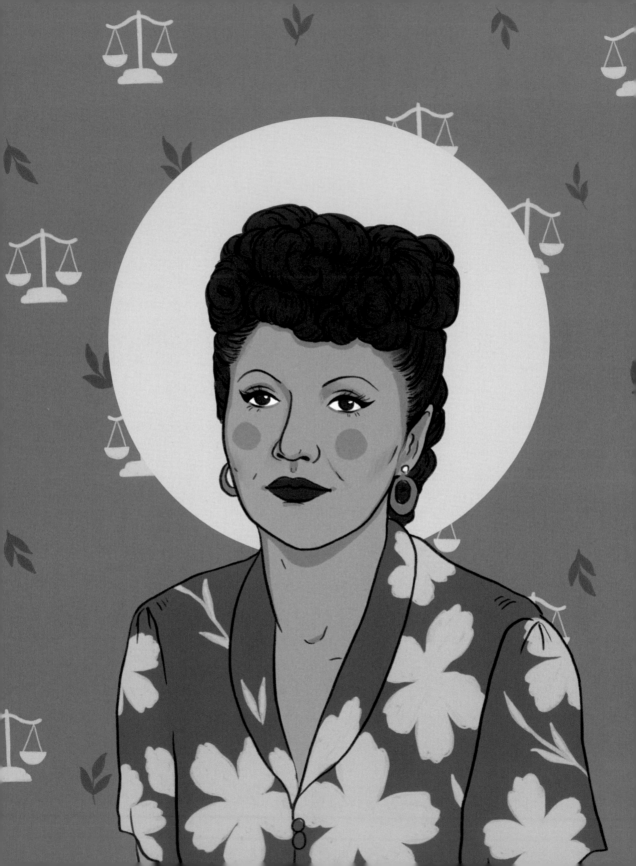

ELIZABETH PERATROVICH

Tlingit

1911–1958 • ALASKA NATIVE CIVIL RIGHTS ACTIVIST

When Elizabeth Peratrovich was growing up as a Tlingit person in the U.S. territory of Alaska, she was not allowed in certain restaurants, attended segregated schools, used segregated hospitals and theaters, and more. Even though she was on her own homelands, she was not considered equal under the law. These early experiences of discrimination would inspire her to become an influential civil rights activist.

Elizabeth was born in Petersburg, Alaska, and was adopted as an infant by a Tlingit couple in Sitka. She grew up speaking Tlingit at home and practiced subsistence living with her family. Her father was a civil rights activist and worked with the Alaska Native Brotherhood, an organization that fought for U.S. citizenship for Alaska Natives, pushed to abolish racial prejudice, promoted Native solidarity, and advocated for fishing and mineral rights for Natives. As a young woman, Elizabeth followed in her father's activist footsteps when she and her husband, Roy, moved from Klawock to Juneau to serve as the chairs of the Alaska Native Brotherhood and Sisterhood. This move allowed them to get involved in regional politics and become advocates for anti-discrimination legislation.

After a failed attempt to pass an anti-discrimination act in 1943, the act was again brought up for a vote in 1945. At the territorial legislative hearing, one of the Alaska senators said of the Alaska Native people fighting for equality, "Who are these people, barely out of savagery, who want to associate with us whites with five thousand years of recorded civilization behind us?" When it was time for public comments, Elizabeth famously said, "I would not have expected that I, who am barely out of savagery, would have to remind the gentlemen with five thousand years of recorded civilization behind them of our Bill of Rights." The Anti-Discrimination Act of 1945 passed, making it illegal to discriminate based on race. It was the first such act in U.S. history, passing fourteen years before Alaska became a state and nearly twenty years before the federal Civil Rights Act of 1964 became law.

Unfortunately, Elizabeth's life was cut short when she passed away from breast cancer in 1958 at the age of forty-seven. Today, her legacy is honored in Alaska with a holiday celebrated on February 16, the date the Anti-Discrimination Act was signed. In 2020, she was featured on the back of a U.S. $1 coin.

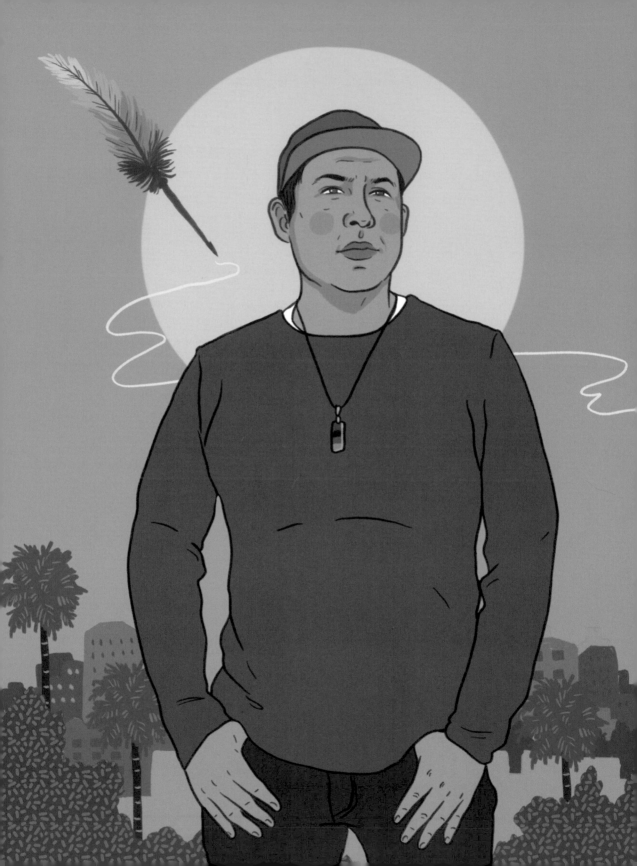

TOMMY ORANGE

Cheyenne and Arapaho

1982– • AUTHOR

In 2018, Tommy Orange's debut novel *There There* made waves on the literary scene for its incredible storytelling and diverse range of Native representation. Set in the urban Indian community of Oakland, California, the novel follows a group of intertwined characters, representing many stories and facets of urban Native life. The story reflects both Tommy's own background and also what he wished to see in books.

Tommy grew up in Oakland, but his ties to his Cheyenne and Arapaho heritage were strengthened by visits to his father's family in Oklahoma. It wasn't until later in his life that he became involved in the local urban Native community, working for several organizations and undertaking a storytelling project where he collaborated with community members to share their personal stories. It was those stories that inspired him to write *There There*, while he was pursuing his master's degree in creative writing at the Institute of American Indian Arts in Santa Fe, New Mexico. He says, "We're pretty invisible, Native people, in movies and TV shows and literature, so I was feeling like I wanted to try to tell a story that hadn't been told about a community that people know too little about." The book was a *New York Times* best seller and was one of the most decorated novels of 2018: it was a finalist for the Pulitzer Prize, won an American Book Award, was long-listed for a National Book Award, and was short-listed for the Andrew Carnegie Medal for Excellence in Fiction, among others.

Tommy now lives with his wife and son in Angels Camp, a small town in Northern California, where he continues to write and publish short stories, opinion pieces on Native representation, and other works. He is a mentor and instructor for the creative writing master's degree program at the Institute of American Indian Arts, where he is helping to shape the next generation of Native writers.

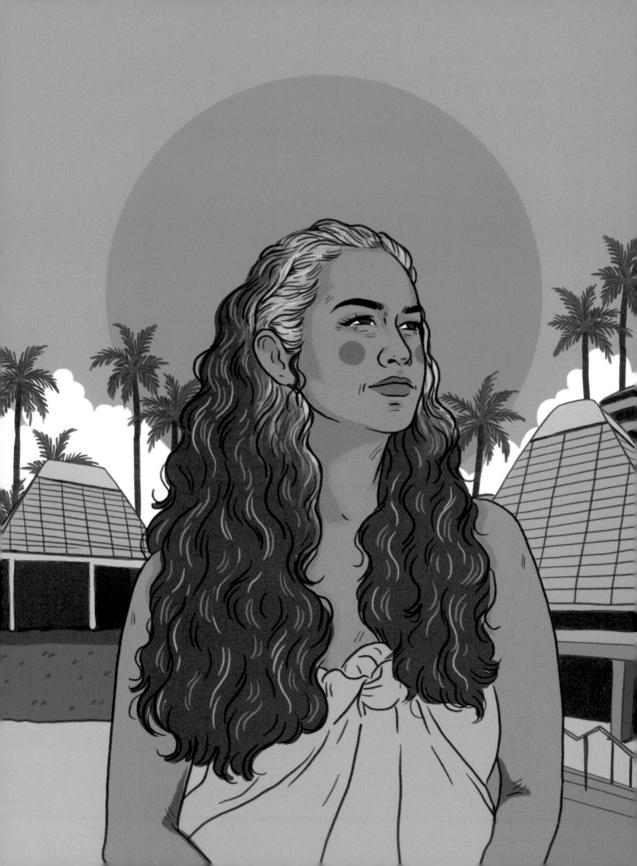

HAUNANI-KAY TRASK

Kanaka Maoli

1949– • SCHOLAR, POET, AND ACTIVIST

Haunani-Kay Trask is a Hawaiian nationalist, educator, political scientist, author, poet, and activist. She was born in California but grew up on Oʻahu, and comes from a long line of orators, resistors, and leaders. She is an unapologetic and internationally recognized voice on Hawaiian sovereignty and the impacts of colonization in Hawaiʻi. She was part of the movement to help reshape the way many Kānaka Maoli saw their Hawaiian identity—not just as a cultural identity, but a political identity tied to a sovereign nation and kingdom outside of the United States.

While studying for her PhD in the mid-1970s, Haunani-Kay became involved in feminist organizing, worked with the Black Panther Party, and protested the Vietnam War. When Hawaiian activists began the movement to reclaim the island of Kahoʻolawe from U.S. military occupation and bombing around the same time, she knew she was needed back home. She returned to Hawaiʻi and put her dissertation on hold for two years so she could be involved in the beginnings of what became known as the Aloha ʻĀina movement. In 1987, she became a founding member of Ka Lāhui Hawaiʻi, the largest sovereignty organization in Hawaiʻi. Haunani-Kay is now one of the foremost leaders of the Hawaiian sovereignty movement, advocating for the return of Hawaiʻi to the Kānaka Maoli and arguing against the illegal annexation at the United Nations Permanent Forum on Indigenous Issues and at human rights conferences and gatherings all over the world.

In addition to her political organizing work, Haunani-Kay has had a distinguished career as an educator, serving as a professor at the University of Hawaiʻi at Mānoa, where she was also the director of the Center for Hawaiian Studies for nearly ten years. She is also the author of two poetry books, two scholarly books, and many essays and speeches, as well as the co-writer and co-producer of the award-winning 1993 documentary *Act of War: The Overthrow of the Hawaiian Nation*. Her speeches and writings are sources of power for those involved in resistance movements worldwide and reflect her deep love of her culture. She says, "Our culture can't just be ornamental and recreational. . . . Our culture has to be the core of our resistance—the core of our anger, the core of our mana. *That's* what culture is for."

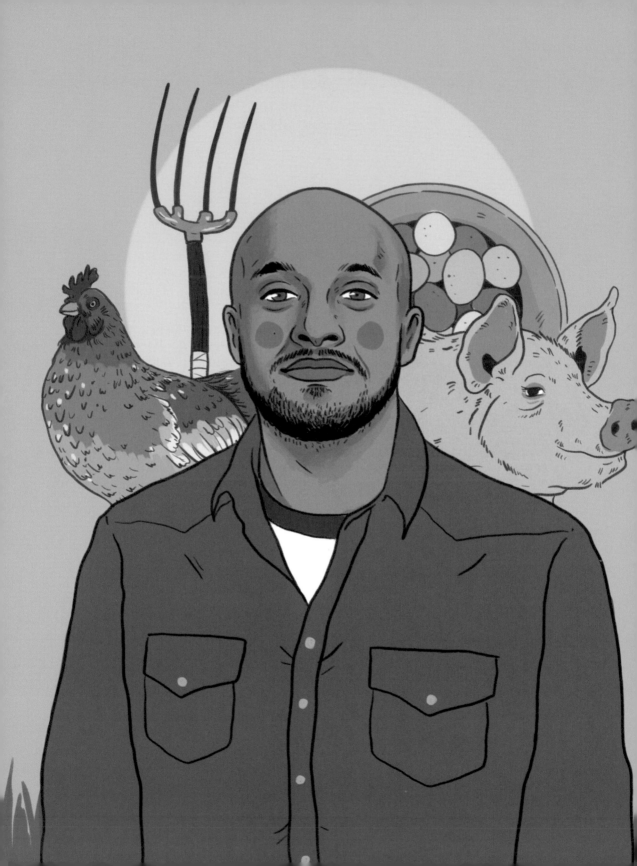

CHRIS NEWMAN

Choptico Band Piscataway

C. 1980– • FARMER AND LAND RECLAMATION AND FOOD SOVEREIGNTY ADVOCATE

Chris Newman was working in a high-stress software job in Washington, D.C., when his health started to deteriorate. It was clear that stress was taking a toll on his body, so he and his wife, Annie, decided to make a dramatic life change. In 2016, they moved to rural Virginia, where they now run Sylvanaqua Farms on forty acres in Montross, an area where Chris's Piscataway ancestors had lived and stewarded the land for generations. Chris started Sylvanaqua with the goal of drawing upon the food cultivation knowledge of his Indigenous and Black ancestors. Now as a food sovereignty advocate and critic of industrial farming, Chris is working to transform the food systems in his region and consider large farms from a new perspective. When people claim that small farms are the only way to produce food sustainably, he reminds them of the ways Indigenous people "sustainably managed large foodscapes" (which are referred to as food forests), before European contact. These forests were planted and cultivated to mirror how plants grow in the wild, placing plants strategically to derive nutrients and protection from other plant species. When settlers arrived and were amazed by the abundance of food sources, Chris says, "They didn't realize that they were basically on a farm. It didn't look like anything they would think of as a food-producing landscape." Now Chris is raising money for a farm collective that would bring together a group of farmers to combine resources and expertise to produce enough food to supply several full-time markets in the Washington, D.C., area. To Chris, approaching large farms from an Indigenous perspective can be a means to reclaim and restore entire ecosystems—rather than smaller plots of land—in addition to providing stable jobs and income.

Chris is also unafraid to speak forcefully about the racism present in the agricultural sector, pointing to the racial disparities in land and farm ownership; barriers to access and funds for Indigenous, Black, and other people of color interested in farming; and the fact that painful histories of enslavement and genocide can make connecting to the land through agriculture complicated and challenging for folks from those groups. On his blog, he writes thoughtful and unapologetic essays with titles like, "Yes, Native Americans Fundamentally Altered Our Environments," and "Stop Yelling about What Poor People Eat," that break down mainstream misconceptions, stereotypes, and faulty scientific studies about food and farming, and call out racism and anti-Indigenous perspectives in the food world.

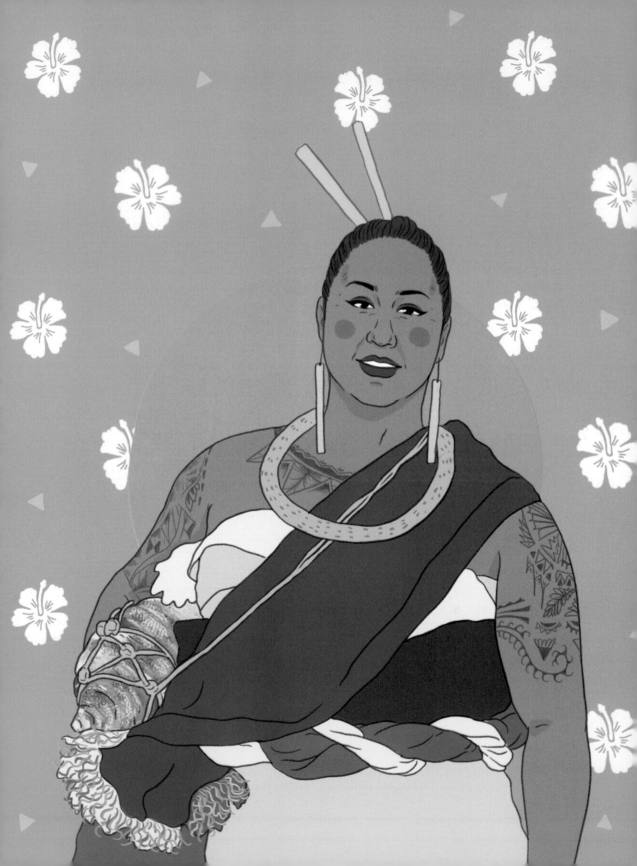

HINALEIMOANA WONG-KALU

Kanaka Maoli

1975– • TEACHER AND CULTURE KEEPER

Hinaleimoana Wong-Kalu, or Kumu Hina, is a renowned and respected Kanaka Maoli educator and cultural practitioner (kumu means teacher). Born on the island of Oʻahu, Kumu Hina grew up attending Kamehameha Schools, which are the schools that Princess Bernice Pauahi Bishop established for Native Hawaiian students. She then studied at the University of Hawaiʻi. Kumu Hina is fluent in ʻŌlelo Hawaiʻi (Hawaiian language) as well as several other Polynesian languages, and she is a keeper of many traditional Kanaka Maoli cultural practices such as hula and oli (chants).

Kumu Hina is an ardent supporter of Kanaka Maoli rights and sovereignty and is a māhū advocate. Māhū is a Hawaiian term for those born "in the middle" who embody both the kāne (male) and the wahine (female) spirit—somewhat akin to what Western society would understand as transgender. Kumu Hina identifies as māhūwahine and says, "Prior to Western contact, Hawaiian society embraced māhū as caretakers, healers, and teachers of ancient tradition. But colonization and Christianity led to many changes, including turning māhū from an honorific to a derogatory term. I'm fortunate to now be in a position where I can help restore māhū to its proper place as a word of pride, dignity, and respect."

Since 2015, Kumu Hina has been deeply involved in the movement to stop the construction of the Thirty Meter Telescope on top of Mauna Kea, a mountain on the island of Hawaiʻi that is a sacred site for Native Hawaiians. She has helped run the daily cultural protocol at Puʻuhonua o Puʻuhuluhulu, the resistance camp on Mauna Kea, as well as composing chants, songs, and hula for the movement. She also has testified before the Hawaiian state legislature to advocate for the protection of the mountain. Though she is proud of her identity as māhūwahine and advocacy for māhū rights, she maintains that she is Kanaka first, and it is only non-Hawaiians who try to limit her with labels. "When I advocate for the Native Hawaiian community—for our Native rights, whether it be gathering rights or rights to practice our language and culture—I am by default advocating for gender equity and gender expression in a manner that is consistent with our culture."

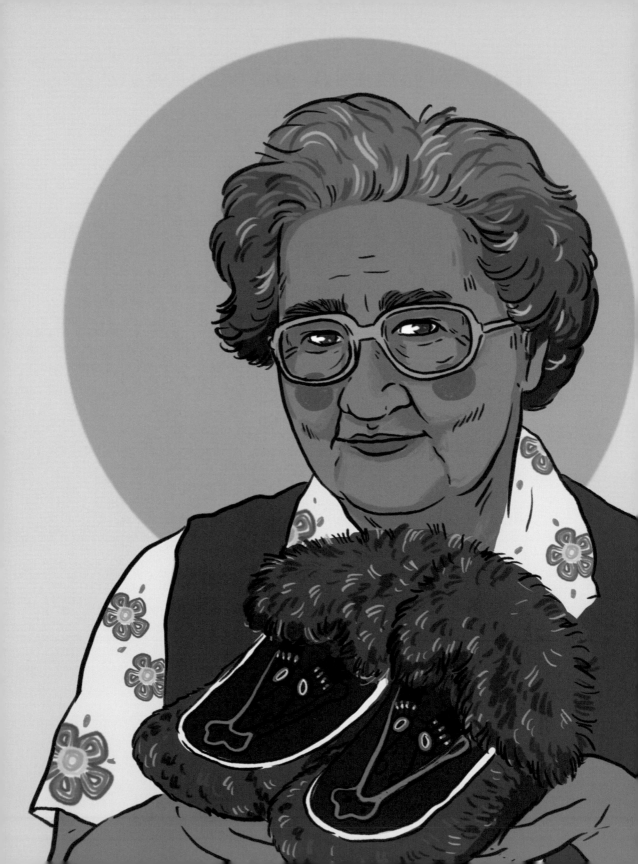

MABEL PIKE

Tlingit

1920–2012 • BEADWORK AND MOCCASIN ARTIST

Mabel Pike was a celebrated beadworker and moccasin maker, known for her beautiful beaded and fur-lined moccasins as well as for her generosity of spirit and willingness to teach and share her skills with others. She was born in Douglas, Alaska, and at the age of six, her great-grandmother taught her how to bead. After their village in Douglas burned down, she and her family moved to Juneau in 1926, and she and her sisters began to sell their beaded moccasins. She created most of her own designs, which were primarily traditional, although she did also create abstract designs that incorporated Tlingit colors and themes.

In addition to her beading and sewing, throughout her life, Mabel worked to share Tlingit language, culture, and stories. She was employed as a dorm matron at Mt. Edgecumbe High School, a boarding school for Alaska Native students; worked as a nurse's aide; and volunteered with the statewide radio to translate stories into the Tlingit language. She also had a close relationship with the Alaska Native Heritage Center in Anchorage, where she served as a board member and instructor.

Mabel was an Alaska Native master artist, and her moccasins are held in museum collections throughout Alaska and the world. She also taught beadwork in local high schools and at the University of Alaska Anchorage. She also had a special relationship with Stanford University, where she would fly thousands of miles each year to serve as an artist in residence, guiding hundreds of Indigenous students through the steps of making moccasins. She continued her visits to California into her nineties and continued to teach and share her skills throughout Alaska until her death in 2012 at age ninety-two.

She is remembered for her beautiful work but also for her sense of humor, spirit, and dedication to sharing her craft. In 2011, the online arts platform Etsy traveled to her home to film her at work for a series on artists, makers, and crafters. In the video, she says, "I just lose myself in my sewing. I don't know how to describe it. You know when I start beading, I'm so absorbed in what I'm doing, I forget everything. I'm sewing and I'm creating a design, and I just don't know how to describe it, I just lose myself in it. . . . When I finish a pair of moccasins, I sure hate to part with them. I'm not in this for money making. I do my sewing because that's my life, that's always been my life, from the day I was six years old."

WHOSE LAND ARE YOU ON?

Everything you see on the map on pages 46 and 47 is Indigenous land. Not was or will be—it already is. Whether you sit on the grass in Central Park in New York City or wander through Monument Valley within the borders of the Navajo Nation, you are on Native land. Since time immemorial, Indigenous people have had a relationship with the ground beneath our feet, with the spaces now occupied by cities, sprawling suburbs, or even rural farmland; in fact, these structures and communities exist only because Native people were displaced from that land. Even though colonization attempted to sever the ties between Native people and their homelands, these relationships still exist. Understanding our own relationship to the people whose land we occupy is an important first step toward disrupting the harmful results of ongoing colonization.

Do you know the name of the Indigenous nation or nations on whose land your house is built? What about where you grew up? Attended school? Went on a vacation? Where you work? If you don't know, it's time to find out. You can start with a resource like Native-Land.ca, on which the map in this book was based, and then verify the information through other sources like tribal websites, local community organizations, or universities. Then find out what those communities are up to today—have they been displaced to other lands? If so, where are they now? Is the local tribal nation still active in your area? If not, is there a local urban Native organization? For many cities and towns, it may feel as if there isn't a Native presence or hasn't been one for a very long time, but there are Native people everywhere.

Once you learn whose land you're on, how do you honor that relationship? It is becoming more common to hear a "land acknowledgment" at the beginning of some public events, conferences, or talks. Land acknowledgments are more common in some other settler colonial nations, like the places currently known as Canada, Australia, and New Zealand. These acknowledgments vary, but they usually give the name of the community on whose land the event is occurring. Although these acknowledgments are symbolic, they are important because they center Native nations and disrupt the status quo. However, these acknowledgments are just the first step. Building relationships with Native people should be about action, not just a checkbox at the beginning of an event.

What can those actions look like? For settlers and non-Natives, it starts with acknowledging the invisibility and erasure of Native people and working to interrupt it. When events are planned, make sure there is a local Native presence. Invite (and pay) local elders to offer opening remarks and to be on advisory committees. Look closely at the language used on websites, forms, and fliers to see whether it privileges colonial

understandings of place. If it does, then petition to have it changed to be more inclusive. All institutional "diversity" initiatives should have an Indigenous presence. Think about symbolic visual representations—like public art and the names of buildings and streets— and how they can honor local tribes. Find out what the local Indigenous issues are and how you can offer your support through monetary donations and/or volunteering. Finally, decolonization cannot occur without the rematriation (return) of Indigenous land to Indigenous people. There are initiatives throughout the United States that are working to make this a reality, including organizations such as Real Rent Duwamish in Seattle that allow settlers to pay rent to the local Native community for the use of Native land. If no such organization exists in your area, consider starting one. Whatever steps you take, make sure that your aim is always to center Indigenous perspectives and voices.

For Native folks, if we are not residing on our own homelands, we are on other relatives' homelands and should work to be in good relation with them by learning about local issues and causes, supporting community events, and prioritizing local voices whenever possible. As a Native person who spends most of her time away from her homelands, I always feel more connected and at home when I have a relationship with the local Native community.

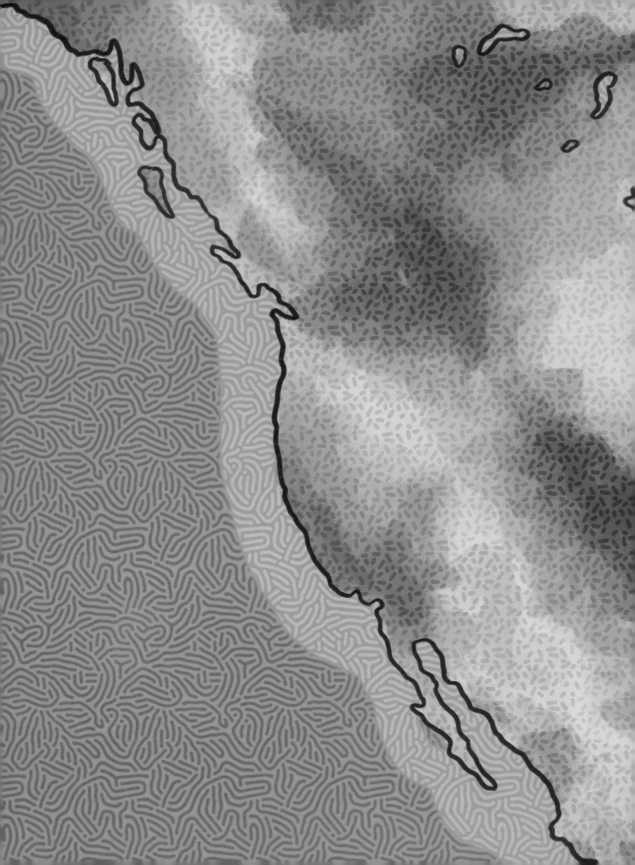

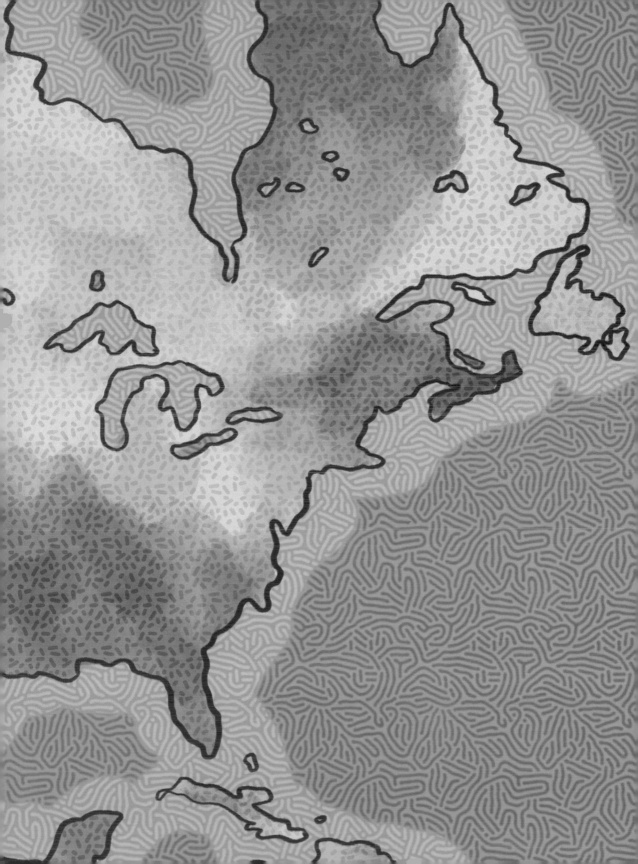

JANET MOCK

Kanaka Maoli

1983– • AUTHOR, ENTERTAINER, AND
TRANSGENDER RIGHTS ADVOCATE

Janet Mock is a well-known author, talk show host, TV producer, director, and transgender rights advocate, who grew up in urban Honolulu with her Native Hawaiian mother and African American father. Janet always knew who she was and began her gender transition as a freshman in high school. She spent some of her childhood in Texas and California, where she struggled in school and socially, but moved back to Hawai'i when she was twelve to live with her mother. She credits her experiences growing up in Hawai'i—where she had positive role models in trans friends, teachers, and community members—as helping her to feel comfortable with her identity at a young age. After graduating from the University of Hawai'i at Mānoa, she attended New York University and earned a master's degree in journalism. She publicly came out as trans in an article in *Marie Claire* in 2011, while she was working as a staff editor at *People* magazine. The next year, her memoir *Redefining Realness*, which is about her experiences in adolescence, was published and became a *New York Times* best seller. She went on to host her own pop culture talk show, *So POPular!*, while continuing to write, report, and contribute to many other media outlets.

In 2018, Janet became a writer, producer, and director for the award-winning FX show *Pose*, which follows the lives of five trans women in the New York City ballroom scene in the late 1980s. She is the first transgender woman of color to write and direct any television episode, and the show has been lauded for its inclusion of trans actors and an accurate representations of trans life.

In 2017, she spoke at the Women's March in Washington, D.C., calling attention to the role and struggles of trans women in the feminist movement and for the need to recognize those who came before. She said, "I stand here today as the daughter of a Native Hawaiian woman and a Black veteran from Texas. I stand here as the first person in my family to go to college. I stand here as someone who has written herself onto this stage to unapologetically proclaim that I am a trans woman-writer-activist-revolutionary of color. And I stand here today because of the work of my forebears, from Sojourner to Sylvia, from Ella to Audre, from Harriet to Marsha." Janet continues to build on the legacy of those women, forging a path for others to follow.

AARON YAZZIE

Diné (Navajo)

1986– • ENGINEER

In many ways, Dinétah, the homelands of the Navajo Nation, looks like Mars. The red earth, deep canyons, and high mesas of the Red Planet remind Aaron Yazzie, a mechanical engineer at NASA's Jet Propulsion Laboratory (JPL), of his home. Growing up in Holbrook, Arizona, a border town of the Navajo Nation, Aaron was always interested in science and engineering. He attended Stanford University, where he studied mechanical engineering, and after graduating in 2008, he began working at JPL, designing and manufacturing components for the Mars rovers and landers. The ultimate goal of his work is to enable NASA to collect rocks and soil from other planets. He worked on the Curiosity rover mission from 2011 to 2013 and was in charge of designing and building a pressure inlet on the InSight lander, which launched in 2018. This tiny piece of equipment was responsible for getting a stable reading of Mars's atmospheric pressure, which is an important piece of data for NASA scientists. Aaron's next project was with the Mars 2020 project, where he was in charge of drill bits that the rover will use to take soil and rock samples for the new mission. These samples will eventually be sent back to Earth for the first time.

As one of fewer than ten Native people working at JPL, Aaron is committed to reaching out to Native youth interested in STEM (science, technology, engineering, and mathematics) fields. He works with the American Indian Science and Engineering Society, hosts visiting Native student groups at the JPL campus, and travels to present to Native communities far and wide. As he continues to explore the universe, he is committed to giving back to Native communities. He also knows that his people have always held important knowledge about the stars and the night sky. To Aaron, Diné understandings of the universe complement and build on the knowledge he has gained in his JPL labs, working together to build a full and complete picture of our place in the galaxy. He says, "As Navajo children, we are told stories of how all these constellations in the sky came to be, because we are taught it's important to know your origins. . . . I realized the space exploration we do is all an expansion of my childhood lesson: to better understand our own existence in the world, and the universe that created us."

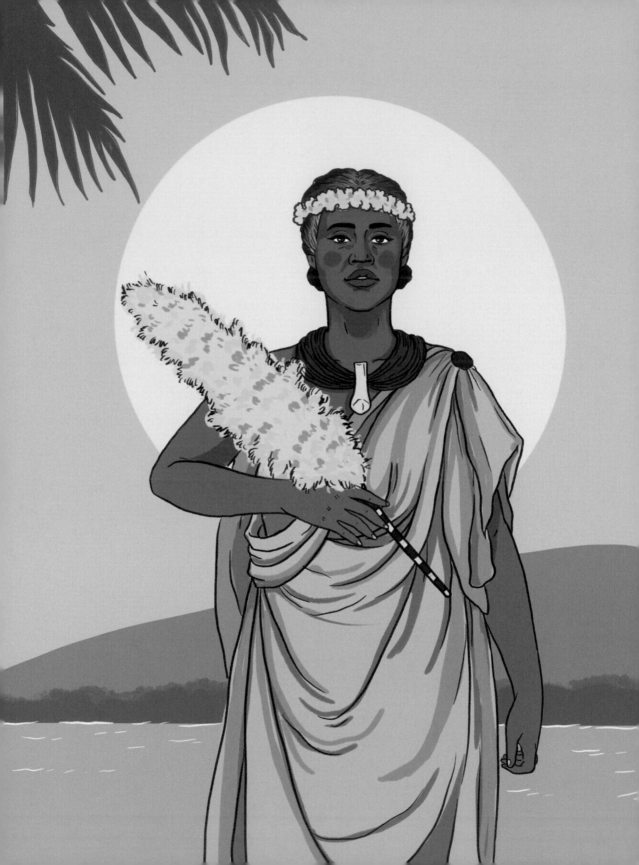

KA'AHUMANU

Kanaka Maoli

1768–1832 • HAWAIIAN LEADER

Ka'ahumanu was a wife of Hawaiian ruler Kamehameha I and co-led the Hawaiian Kingdom through the reign of three kings in a role much like a present-day prime minister. Ka'ahumanu was born on the island of Maui and came from two powerful and politically connected families. When she was thirteen years old, her father arranged for her to marry Kamehameha I, and she became his favorite and most influential wife. Before Kamehameha I, the islands of Hawai'i were independent kingdoms, with each ruled by its own monarch. Kamehameha I waged a war, encouraged by Ka'ahumanu, to unite the islands. He succeeded and became the first ruler of the Hawaiian Kingdom with Ka'ahumanu by his side as a powerful advisor.

When Kamehameha I died in 1819, Ka'ahumanu said it had been his wish for her to continue to lead the Hawaiian Kingdom with Kamehameha II, his son and successor. The council of advisors created the role of Kuhina Nui for her, formally empowering her to serve as co-regent. In this role, she influenced many policy changes such as removing traditional Hawaiian kapu (taboos) like men and women eating together. This set the stage for the removal of many other traditional beliefs around the separation of the sexes and allowed Ka'ahumanu to assume more power as a leader. She co-led the Hawaiian Kingdom as Kuhina Nui until 1832, through the reigns of Kamehameha II and Kamehameha III. Ka'ahumanu and Kamehameha III established the first treaty with the United States in 1826 under the John Quincy Adams administration. This treaty assumed the debts of Native Hawaiians with American traders, repaying the debts in large amounts of expensive sandalwood. It also was a free trade agreement that allowed American traders to enter Hawaiian ports for business.

In 1827, after a trip to the Windward Islands in the West Indies, Ka'ahumanu fell ill and eventually passed away in 1832. She had converted to Christianity in 1824, and during her sickness, missionaries printed a New Testament Bible in Hawaiian language for her; this is thought to be the first Hawaiian language Bible. Her legacy as a powerful female ruler is recognized today in Hawai'i through the Ka'ahumanu Society, a civic club that celebrates Hawaiian culture and looks after elders.

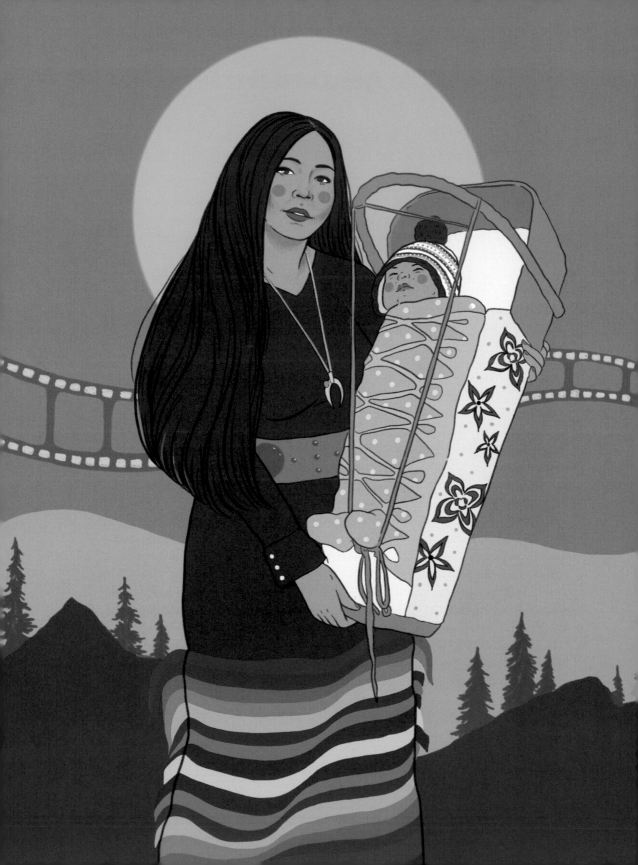

MATIKA WILBUR

Tulalip, Swinomish

1984– • PHOTOGRAPHER AND STORYTELLER

Matika Wilbur is a keeper of stories. As a photographer, writer, and visual storyteller, she has spent more than ten years traveling throughout Indian Country, with the goal of photographing all of the tribes in what is currently known as the United States. Her project, called Project 562 for the 562 tribes that were federally recognized when she began in 2011, has the goal of "changing the way we see Native America." Born in Anacortes, Washington, and raised on her homelands in Swinomish, Matika grew up close to her community and cultural practices. Trained as a photographer at the Brooks Institute in California, she began her career in fashion and commercial work in Los Angeles. Before focusing on photography as a tool for social justice, Matika returned to her community and taught primary education at the Tulalip tribal school for five years. It was there, working with her Native students, that she realized they had no access to images and stories of the power of Native people, only a curriculum that relied on stereotypes. With the guidance of her elders and others in her community, she sold everything in her Seattle apartment and set out on the road, eventually moving full time into "The Big Girl," her RV, to continue her journey.

As she travels across Indigenous homelands, Matika creates stunning and powerful portraits of community members in every Native nation she visits. Historically, photographs of Native people were used to document a "vanishing race," and subjects were often posed and given costumes to wear that reflected what the public thought Natives "should" look like. To subvert this history, Matika asks her participants to wear whatever they like and to choose the location of their portrait. In addition to photographing her subjects, Matika also engages in long sharing sessions with them to hear what stories and causes they would like the public to know about. Through this work, she has learned not only about family and tribal histories and the effects of colonialism on everything from ceremony to food systems but also about the ways that communities have resisted, revitalized, and found joy through cultural practices.

Matika shares these photos and stories in museum and gallery shows, as well as on her website and social media. She also travels extensively to give talks to audiences large and small, Native and non-Native, to share the lessons, voices, and photos from her journeys. She says, "My dream is that our children are given images that are more useful, truthful, and beautiful."

In addition to her speaking and artwork, she is the co-creator and co-host of *All My Relations*, a podcast that builds on her years of learning from other Indigenous people. The show focuses on the idea that relationships are foundational to Native people—their relationships to the land, to nonhuman relatives, and to one another.

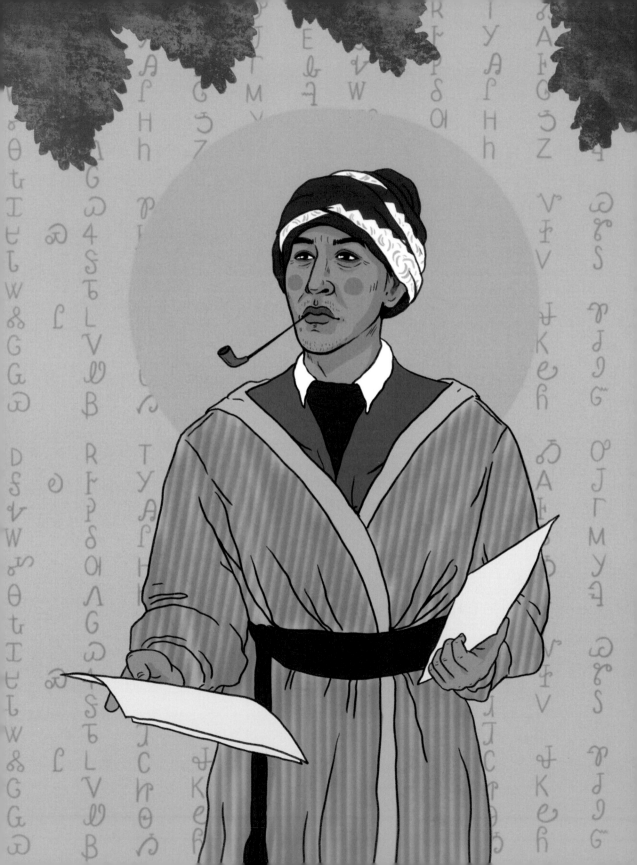

SEQUOYAH

Cherokee

C. 1770–1843 • CREATOR OF THE CHEROKEE SYLLABARY

Born sometime in the 1770s within the boundaries of the Cherokee Nation (in what is currently known as Tennessee, North Carolina, and Georgia), Sequoyah was a Cherokee silversmith, blacksmith, trader, and creator of the Cherokee syllabary, the writing system that allowed Cherokee people to read and write in their own language—the first of its kind.

While Sequoyah did not speak or write English, he understood the value of what he called the English "talking leaves"—letters, documents, pamphlets, and books—and their ability to communicate without spoken language. So, in the early 1800s, he set out to create Cherokee talking leaves, a long and arduous journey. Because of distrust of the unknown and his dogged focus on the task, fellow Cherokees and non-Cherokees thought he was unstable and dismissed his work as useless. But he continued, undaunted, working on the written language for over twelve years. By listening closely and analyzing spoken Cherokee, he eventually realized that there was a set of eighty-five distinct syllables used throughout the language. So, he assigned each syllable a symbol, which allowed Cherokee speakers to easily transition to writing and reading.

Sequoyah taught his daughter, Ayokeh, to use the syllabary at a young age; her literacy was used to prove that his system worked after he was accused of witchcraft by his own people and brought to trial. His accusers, convinced that the talking leaves worked through bad magic, asked Sequoyah to write to Ayokeh, who read the messages aloud. Ultimately, his accusers became convinced that Sequoyah's innovation had nothing to do with witchcraft, and Cherokee leaders asked to be taught to read and write.

In 1825, the Cherokee Nation officially adopted the syllabary, and the population became overwhelmingly literate, unlike the local white population. This adoption of the syllabary occurred during a crucial time in Cherokee history, as pressure was mounting from the U.S. government to forcibly remove Cherokees to "Indian Territory." The syllabary allowed the Cherokee Nation to establish the first Native-language newspaper, the *Cherokee Phoenix*, in 1828, and write communications in the Cherokee language to fight back. Despite their efforts, the Cherokee people were forcibly removed on what become known as the Trail of Tears in 1831.

Sequoyah had moved to Indian Territory in 1829, prior to removal. Later in his life, wishing to see the Cherokee Nation reunited again, he traveled to Mexico in search of the Cherokee people who had escaped southward during the time of removal, and he ultimately passed away there, though his official gravesite has never been found. Sequoyah's syllabary is still used by the three Cherokee tribal nations today, in official government documents, books, newspapers, and school curriculum—it is even one of the languages recognized by Apple's operating system on iPhones, iPads, and Mac computers.

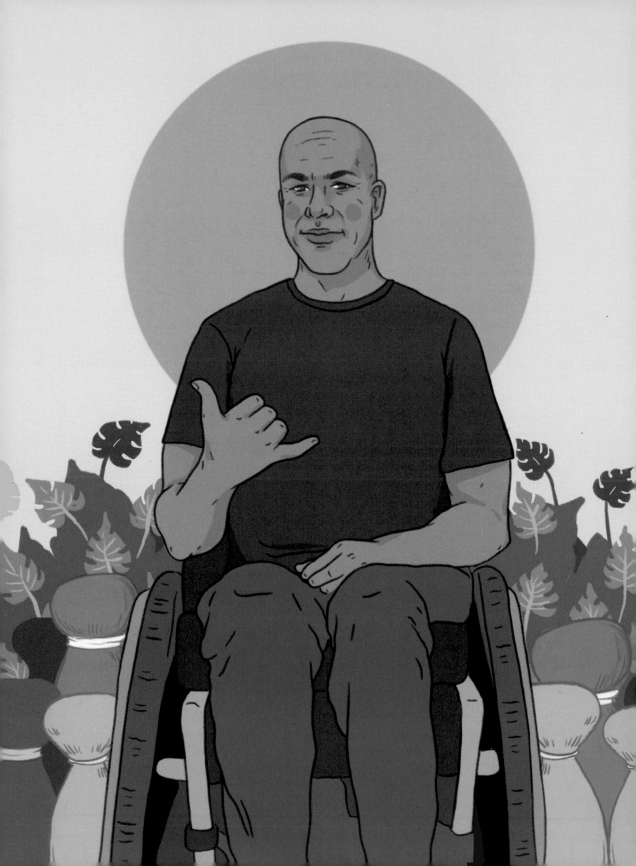

KALIM SMITH

Muscogee Creek

1975– • GOURD ARTIST AND IPU MAKER

Kalim Smith is an artist who crosses borders of Indigeneity to bring together traditions from Southern California tribal cultures and Kanaka Maoli culture as a maker of ipu hula and ipu heke (Hawaiian gourd drums). He comes from a multicultural family, having African American, British, and Muscogee Creek heritage, but was born and raised within Kumeyaay homelands and is a community member on the Viejas Reservation near San Diego, where he was deeply involved in learning Southern California Native languages and traditions of the Kumeyaay, Cocopah, and Luiseño.

As a young man, Kalim began growing gourds for his Cocopah relatives, since many tribes from the lands that are now known as Arizona and Southern California use them for a variety of purposes, such as drinking vessels and rattles that accompany bird songs. Kalim's wife, Kahelelani, is Kanaka and a kumu hula (hula teacher), and Kalim began to use his gourds to make ipu for her hālau (hula school). Ipu hula (a single gourd) and ipu heke (a pairing of two gourds) are traditional percussion instruments in Hawai'i that are made from varieties of gourds grown on the islands. Kalim experimented with making ipu from gourd varieties native to California, beginning by making ipu for family and friends as a hobby.

In 2011, Kalim was a doctoral student in cultural anthropology at University of California, Berkeley and studying and teaching Luiseño language, when he became paralyzed from the waist down in an accident. As part of his ongoing healing process, he decided to shift his professional goals away from academia and turned his attention to growing Hawaiian plants and making instruments from his gourds full-time. In dealing with his spinal cord injury, he developed trellised growing methods that accommodate his wheelchair and allow him to pick his gourds from below, and he learned new adaptive techniques for his artistry. Finding that Southern California growing conditions are ideal for growing Hawaiian ipu gourds, Kalim created hybrid gourd strains by blending them with varieties from Kumeyaay lands, taking the best of both gourd types to create the perfect drum. Now he is a master artist, and his ipu are highly sought after by all the top hula kumu (teachers) and practitioners throughout Hawai'i. In addition to his ipu work, he is an accomplished Paralympic skier, having won many national races and competed on the U.S. Paralympic Team. He now divides his time between the island of Hawai'i and Southern California, learning traditions from family, relatives, and the land in both communities and highlighting the connection between Indigenous communities across the Pacific.

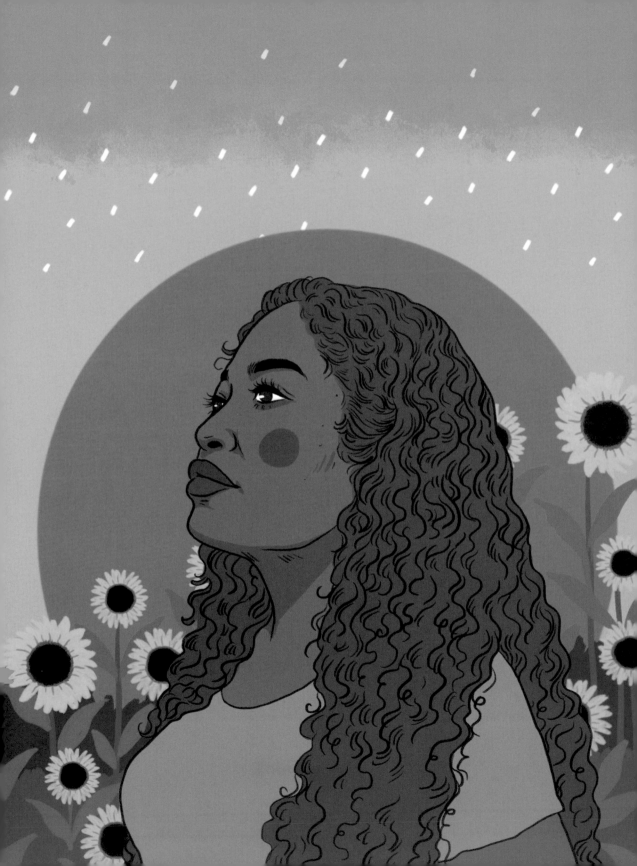

JIHAN GEARON

Diné (Navajo)

1981– • ENVIRONMENTAL JUSTICE ORGANIZER, ARTIST, AND FEMINIST

Jihan Gearon is an Indigenous feminist, painter, organizer, and facilitator and is a leader in Indigenous environmental justice. She is Diné and Black and is from the community of Old Sawmill, Arizona, which is on the Navajo Nation. With a degree in earth systems—with a focus on energy science and technology—from Stanford University, Jihan's interest and passion for environmental justice take many forms. She has worked with several organizations, including the Indigenous Environmental Network and the Climate Justice Alliance, and is the former executive director of the Black Mesa Water Coalition, an organization that protects the land and water for Diné and Hopi people. In 2020, she was named to the NDN Collective's inaugural class of Changemaker fellows, who are "working to defend, develop, and decolonize their communities and Nations."

She identifies as an Indigenous feminist and co-founded an Indigenous feminist organizing school in northern Arizona. Indigenous feminism is rooted in the understanding that colonization and patriarchy are inextricably tied, and it informs every aspect of Jihan's work, including her environmental advocacy. From Jihan's perspective, the future of the Earth depends on Indigenous feminist values, and living in good relation with the land is fundamental to our survival. Right now, the world relies on oil and gas, and decisions about our environmental future are often made or influenced by large corporations thinking about money rather than communities. She sees a different path, what she calls a "just transition feminist economy" that would focus on building relationships between the land and one another to move forward without fossil fuels. To Jihan, having the needs of everyone in our communities met in a way that doesn't damage the earth is the heart of Indigenous feminism.

In 2017, at the age of thirty-six, Jihan was diagnosed with endometrial cancer. As part of her journey of healing, she turned to painting, creating bold, powerful works that feature the animals, people, and other beings that protected, motivated, and transformed her during her recovery. Her paintings bring her passions in life together, showcasing feminine energy, connections with the natural world, and the future of a healthy planet. Jihan says, "Indigenous feminism can change our world, if given the chance. . . . It's about recognizing, naming, and discarding the worldview forced, reinforced, and enforced by this colonial experiment called the United States of America, and picking up the teachings and practices of our ancestors."

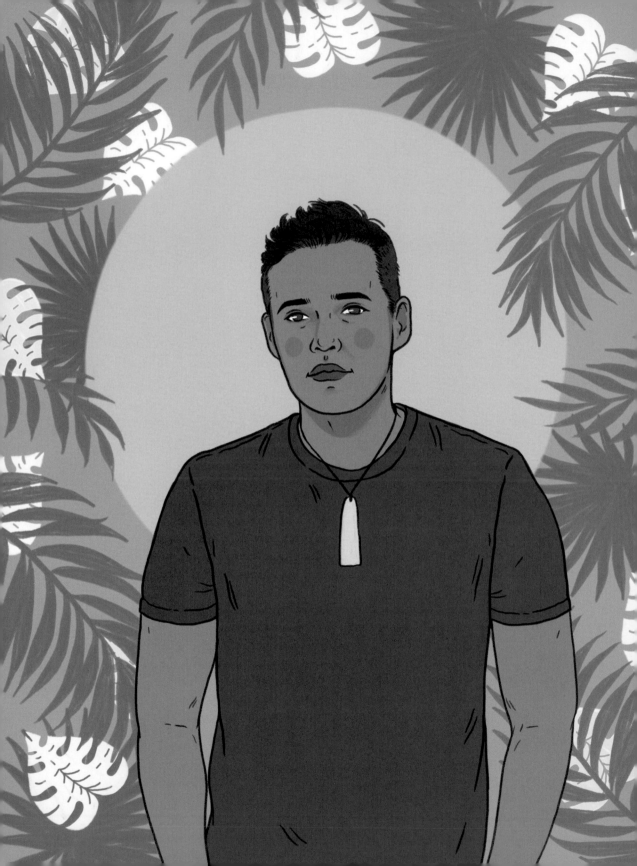

JAMAICA HEOLIMELEIKALANI OSORIO

Kanaka Maoli

1990– • POET, SCHOLAR, AND ACTIVIST

Jamaica Heolimeleikalani Osorio was born and raised in the Pālolo Valley on the island of Oʻahu. Heoli began her educational journey at Ke Kula Kaiapuni ʻO Ānuenue, where she harnessed her Hawaiian language fluency, learning to read and write in Hawaiian before English. An accomplished poet, her poetry captures the beauty, anger, pain, and passion of Hawaiian history and culture and demonstrates the power of a young Hawaiian voice. When she was in high school at Kamehameha Schools, the system of schools in Hawaiʻi for Native Hawaiian students, Heoli and her team were two-time winners of the Brave New Voices International Youth Poetry Grand Slam. In 2009, when she was nineteen and a freshman at Stanford University, she was featured in the HBO documentary *Brave New Voices*, featuring young spoken-word artists; later that year, she performed at the White House for President Obama.

After graduating from Stanford, she went on to receive a master's degree in art and politics from New York University and earned her PhD in Hawaiian literature at the University of Hawaiʻi. Currently, Heoli is an assistant professor of Indigenous and Native Hawaiian politics at the University of Hawaiʻi at Mānoa. As a queer wahine (woman), she brings her perspective to her work and research, examining traditional Hawaiian moʻoleo (stories) through a lens of gender, weaving poetry and storytelling into her academic writing.

Heoli is an ardent defender of Hawaiian sovereignty with deep activist roots. She grew up surrounded by Kanaka Maoli activists, discussing the illegal overthrow of the Kingdom of Hawaiʻi, and observing Hawaiian cultural revival. As the movement against the Thirty Meter Telescope (TMT) on Mauna Kea was at its height in 2019, Heoli was deeply involved as a kiaʻi (protector) at Puʻuhonua o Puʻuhuluhulu, the resistance camp on the mountain. She participated in non-violent direct action, and together with other activists, locked herself with chains and padlocks to a cattle guard on the road for over twelve hours to prevent TMT trucks from bringing in equipment; this was a pivotal moment in the movement. She became a voice for the kiaʻi through her poetry, spoken word, and lectures, with videos circulating and shared widely online. In one of her poems, she tells about the personal impact of the Puʻuhonua and the relationship with the ʻāina (land) on the mountain: "Ask me and I will tell you/that I have been transformed here,/but I won't have the words to quite explain./I will say, 'I don't know exactly who I'll be when this ends, but at the very least, I'll know that this ʻāina did everything it could to feed me.'/And that will be enough to keep me standing."

WHO BELONGS?

To be an Indigenous person means to have ties to a physical place and a people. It is a complex identity to hold, one that doesn't fit easily into the categories of race, citizenship, and heritage set up by the American system. There are millions of Native people in the United States, and as a result, there are millions of ways to identify as a Native person. Our tribes are sovereign nations and therefore have the right to determine who belongs in their nation and who can be a tribal citizen. This is a messy and imperfect process, clouded by generations of colonization, forced removals, forced adoptions by non-Native families, federal policies, and more. In addition, there are multiple types of tribal nations: those recognized by the U.S. government, known as federally recognized tribes; state recognized tribes, who are recognized by state-level governments only; and non-recognized tribes. Within the latter two categories are tribes that have been fighting for federal recognition for decades and others who are categorized by other tribal nations as fraudulent groups, trying to gain resources designated for tribal nations and people. As you can see, none of this is simple or clear-cut.

The bottom line is this: Tribal nations have the right to determine who belongs, but that doesn't mean it is always a fair process. In Indian Country, we often draw upon the idea that "it's not who you claim, it's who claims you," which can be a helpful framework for understanding tribal identity. What relationships do you have? Who are your family and relations? How are we related? It's these relationships that are at the core of what it means to be Indigenous.

BLOOD QUANTUM

How much are you? For many Indigenous people, this is a common question when non-Natives find out about their heritage. It's an often awkward and sometimes painful question and draws upon the history of what is called blood quantum, which is the idea that we can quantify the percentage of "Native blood" that an individual possesses. This idea was introduced by colonization, because colonizers realized that if there were fewer Native people, the colonizers could have more access to Native land and resources. The idea of blood quantum means that Native identity can literally be "bred out"—if a Native person has children with a non-Native person, each subsequent generation is "less Native"—which is an awful concept that doesn't mesh with traditional Native ideas about community and belonging. Despite blood quantum being a tool of colonization, many tribes today still use it as a requirement for enrollment.

DETERMINING CITIZENSHIP

Native nations have many different ways of determining who is considered an enrolled citizen. The following are some ways Native nations determine citizenship.

- **LINEAL DESCENT:** You have an ancestor on a "roll" of citizens, taken at some point in history, and can trace your direct descent from that ancestor.

- **BLOOD QUANTUM:** You possess a minimum blood percentage, often one-fourth, meaning you have at least one grandparent who is "full blood." Some nations require that all of the "blood" comes from their particular nation; others allow blood percentage from any tribal nation, as long as the enrollee is one-fourth overall and has an ancestor enrolled in that nation.

- **FAMILIAL DESCENT:** Your tribal nation blood and connection must come through your mother (matrilineal) or father (patrilineal) to qualify for citizenship.

- **RESIDENCY:** Citizens must be residents of the nation's reservation or homelands (either currently or for a certain period of time).

The following are not considered in determining tribal citizenship.

- **ANCESTRY DNA RESULTS:** There are no tribal nations in the United States that will accept results from an ancestry DNA test for citizenship. The tests are inaccurate, generalized, and based on flawed understandings of Native identity.

- **UNSUBSTANTIATED FAMILY STORIES:** Many non-Native Americans have heard that they have "an Indian" somewhere in their family tree but can't actually substantiate this relation. There are no tribal nations that will accept only your stories for citizenship (and if they do, they're not a real tribal nation), since Native people are incredibly well documented through census records, enrollment records, land records, and internal tribal records.

It is impossible to cover all of the nuances and complications of Native identity and belonging in just a few pages. Note that the explanations offered here apply only to American Indian tribes—Kānaka Maoli and Alaska Native communities have different understandings. Despite all of the rules and regulations, tribal citizenship makes up only one facet of what it means to be an Indigenous person.

The San Francisco Call

SAN FRANCISCO, SUNDAY MORNING, NOVEMBER 28, 1897

HAWAII'S LAST STRUGGLE FOR FREE

STATESMEN OPPOSE
AN

Pettigre

HAWAIIANS
TO BATTL
FOR

Arrival of the
mission En
Wash

JAMES KEAUILUNA KAULIA

Kanaka Maoli

1885–1941 • HAWAIIAN SOVEREIGNTY LEADER

James Keauiluna Kaulia was a dedicated Hawaiian loyalist and patriot, who served as the president of the archipelago-wide ʻAhahui Aloha ʻĀina (Hawaiian Patriot League). At the turn of the nineteenth century, it became clear that the United States was aggressively pursuing the annexation of the Hawaiian Kingdom because of its location between the United States and Asia, a strategic military position in the Pacific. Because of the work of James and ʻAhahui Aloha ʻĀina, no treaty of annexation or any other form of legal merger between the Hawaiian Kingdom and the United States has ever been executed.

Following the 1893 U.S.-backed coup against Queen Liliʻuokalani, Hawaiian patriotic leagues mobilized a mass petition drive against annexation, and James was part of a four-person delegation that traveled to Washington, D.C., to deliver the petitions—signed by over forty thousand people—to the U.S. Senate. Referred to by mainland newspapers as the Hawaiian Commission, James's work, as well as Queen Liliʻuokalani's tireless advocacy, ensured that the senators understood the arguments against annexation. By the time the delegation left Washington in February of 1898, only forty-six of the ninety senators voted for annexation, and the bill did not pass. Unfortunately, on July 7, 1898, President McKinley signed the resolution annexing Hawaiʻi as a territory to the United States, even though the bill did not follow the rules of the U.S. Constitution and remains technically illegal today.

At a gathering of thousands of Hawaiian patriots at the Iolani Palace in 1897, James gave an iconic speech opposing the annexation of Hawaiʻi, saying that "consenting for our nation to be subsumed within America is like agreeing that we, the nation, be buried alive with the many hardships that would follow annexation. . . . Do not be afraid! Stand firm in love for this land and unify in this thought: vigorously protest the annexation of Hawaiʻi with America." Even after annexation, the fight for Hawaiian sovereignty has not stopped. Inspired by the work of James and others like him, thousands of Kānaka Maoli continue to resist U.S. imperialism in Hawaiʻi, and scholars and activists have picked up where the movement left off—educating the public on the illegal overthrow and annexation and bringing research before international bodies like the United Nations to demonstrate that the Kingdom of Hawaiʻi never ceased to be a sovereign nation and should continue to be recognized as such.

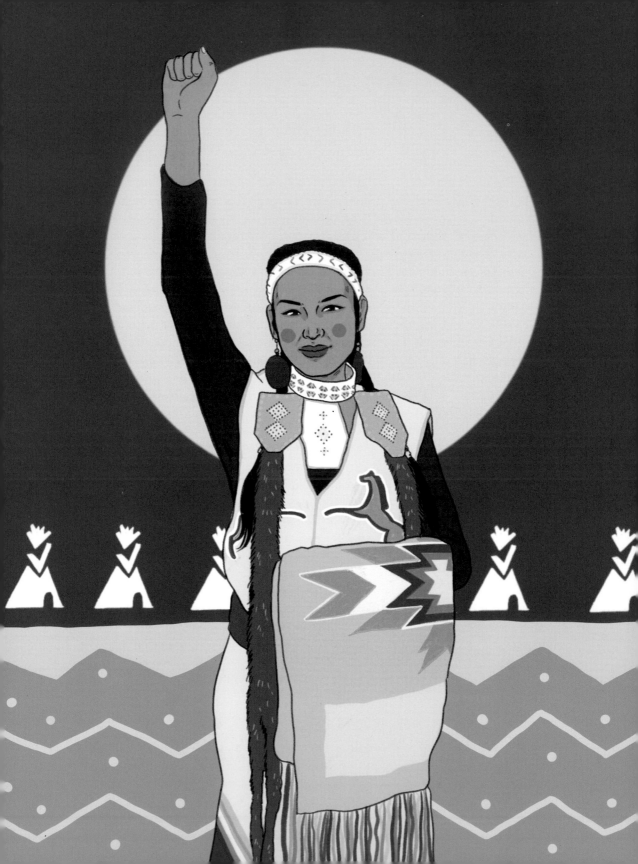

BOBBI JEAN THREE LEGS

Standing Rock Lakota, Cheyenne River Lakota

1992– • ENVIRONMENTAL ACTIVIST

In March 2016, at the age of twenty-three, Bobbi Jean Three Legs found out about the potential impacts of the twelve hundred–mile pipeline, called the Dakota Access Pipeline (DAPL) on her community's land and water, and she was compelled to fight. With the guidance of her family, she planned an 11.1-mile youth run to raise awareness about DAPL and invited the community to participate by going door-to-door in her small town of Wakpala, South Dakota, on the Standing Rock Reservation. Runs to bring attention to causes have long been a part of Lakota community activism, and there is a history of running as a traditional means of delivering messages in Native communities. The run gained local attention, and soon organizers from previous anti-pipeline movements began arriving in Standing Rock to help establish a resistance camp. The Camp of the Sacred Stones was born on LaDonna Brave Bull Allard's land, and Bobbi Jean and her family moved into the camp in support of the movement, which became known as #NoDAPL.

Waniya Locke from the organization People Over Pipelines tasked Bobbi Jean and fellow organizers like Joseph White Eyes and Jasilyn Charger with organizing a longer run from Cannon Ball, North Dakota, to the offices of the U.S. Army Corps of Engineers in Omaha, Nebraska, since the Army Corps was responsible for approving all of the permits for the pipeline. This five hundred–mile run brought together representatives from each of the nine Oceti Sakowin bands. The runs utilized a traditional messenger style, with each runner being replaced as necessary, carrying an eagle staff and tribal flags as they ran. It brought together communities and youth like never before and became the catalyst for many to join the movement. After this successful campaign, Bobbi Jean and fellow activists went on to help organize a run from Standing Rock all the way to Washington, D.C. in July to hand deliver a petition to the Army Corps of Engineers directly.

By September of 2016, support for the #NoDAPL movement had spread throughout the United States and the world, and the resistance camps had grown enormous. Through organizing, hard work, and solidarity, the movement succeeded: in the final days of his presidency, President Obama revoked the permits for DAPL, halting the construction and protecting the land and water. Sadly, within days of President Trump's taking office, he reversed the decision and oil now flows through the pipeline, though communities have not stopped fighting in courtrooms. The Standing Rock nation continues to fight the pipeline through the courts and has won several of the cases, giving hope that the pipeline will be shut down for good.

But Bobbi Jean has not been deterred and has continued to be involved in environmental activism, fighting for the protection of water and land. During the height of #NoDAPL, she said, "I'm obviously going to stand up for what's right, and I'm going to try to stand up for what's best for my people, for my family, for myself, for future generations."

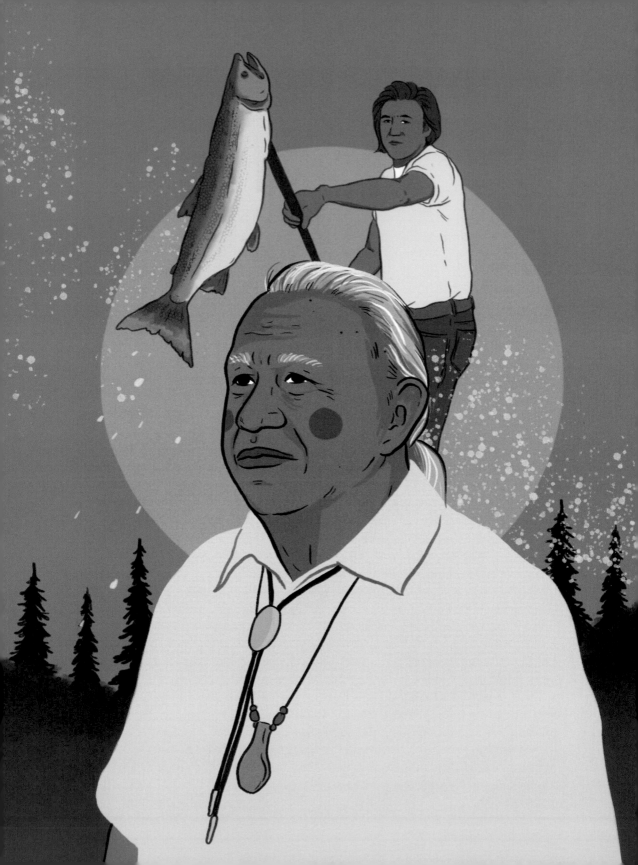

BILLY FRANK JR.

Nisqually

1931–2014 • ENVIRONMENTAL LEADER
AND TREATY RIGHTS ACTIVIST

In 1945, when Billy Frank Jr. was fourteen, he was arrested for the first time, though not the last time, for fishing in his homelands. Although his tribal nation (as well as others in Washington State) had a protected right to fish in their homelands, the state tried to stop them from exercising their rights outside of reservations—often arresting, ticketing, or fining tribal members for "illegal" fishing. Billy knew this had to change.

Billy completed his formal education in ninth grade, went to work as a commercial fisherman and in construction, and then served as a U.S. Marine for two years. Throughout his younger life, he continued to face fines and arrests for fishing; this led to his becoming a leader in a civil disobedience movement to protect tribal fishing rights. During what became known as the Fish Wars in the Pacific Northwest in the 1960s and 1970s, Billy and other tribal members used methods learned from the civil rights movement to stage "fish-ins" and protests to assert the rights to hunting and gathering promised in historic treaties with local tribes. This activism led to a 1974 U.S. Supreme Court case, the *United States v. Washington,* in which Justice George Boldt wrote the decision, affirming that tribal treaties supersede state law and that the rights promised in the treaties extend not just to the tribal nations but to each tribal member. This case is held up as one of the most important modern U.S. Supreme Court cases for tribal sovereignty.

After what is now known as the Boldt decision, Billy was involved in advocacy at the local and government level, befriending and working with elected officials to protect tribal sovereignty, lands, and salmon and serving as the director of the Northwest Indian Fisheries Commission for more than thirty years. But in his words: "I wasn't a policy guy, I was a getting arrested guy." He advocated for fishing rights because he saw hunting and fishing as being directly tied to tribal traditions, sovereignty, and food sovereignty, as well as recognizing nonhuman relatives and their habitats as barometers for the health and well-being of the world. He said, "I believe in the sun and the stars, the water, the tides, the floods, the owls, the hawks flying, the river running, the wind talking. They're measurements. They tell us how healthy things are. How healthy we are. Because we and they are the same. That's what I believe in."

Billy passed away in 2014 at the age of eighty-three, leaving behind an incredible legacy of activism, resistance, and advocacy. He was posthumously awarded the Presidential Medal of Freedom in 2015, and throughout his life, he received countless other humanitarian, activist, and civil rights awards.

SHARICE DAVIDS

Ho-Chunk

1980– • CONGRESSWOMAN

When Sharice Davids ran for the U.S. Congress in 2018, she had the odds stacked against her as an openly gay Native woman, a former mixed martial arts fighter, and a Democrat running against a four-time incumbent Republican in the 3rd Congressional District of Kansas. But she and her supporters fought a hard campaign, earned the trust of voters, and ultimately won, sharing the joy of being the first Native woman elected to Congress alongside Deb Haaland, who is Laguna Pueblo from New Mexico.

Born in 1980, Sharice is the daughter of a single mother who spent twenty years in the U.S. Army. As a first-generation college student, Sharice attended Johnson County Community College and the University of Missouri–Kansas City, before earning a law degree from Cornell Law School. She began practicing martial arts at the age of nineteen and had her amateur debut in 2006. She pursued mixed martial arts professionally for a period of time, including while in law school.

Sharice believes that diversity of representation matters at every level of the government, saying that "when there are more voices at the table and people with different experiences, we will be better equipped to figure out who hasn't been part of this conversation." As part of the U.S. Congress, she serves on the House Committee on Transportation and Infrastructure and the Committee on Small Business and is part of the congressional LGBTQ+ Equality Caucus and the congressional Native American Caucus. When the Violence Against Women Reauthorization Act of 2019 was passed, Sharice presided over the floor of the U.S. House of Representatives, only the second Native woman ever to do so. She strongly advocated for passage of the act and co-sponsored three amendments that would specifically address the Missing and Murdered Indigenous Women epidemic by improving the information sharing and coordination within law enforcement agencies. She was reelected to a second term in 2020 and hopes to continue to advocate for her Native and LGBTQ+ communities in the future.

PAUL JOHN

Yup'ik

1929–2015 • CULTURAL ADVOCATE

Paul John was a respected cultural mentor, Yup'ik language speaker and advocate, orator, and elder for the Yup'ik community. Born in Chefornak, Alaska, Paul was raised in a sod house on the Bering Sea in a family that practiced a traditional subsistence lifestyle— harvesting seals and fish and learning to make clothing and shelter from the resources around him. He was one of the last generations to be raised in a village qasgi (men's community house), where from a young age, he learned cultural knowledge from elders. He strongly believed that young Yup'ik people should learn this way of life as well as the Yup'ik language, which tells the stories and teachings of the land.

Like many Indigenous languages, the Yup'ik language was deeply impacted by colonization, and many Yup'ik people were not raised speaking it, something Paul wanted to change. He said, "In this whole world, whoever we are, if people speak using their own language, they will be presenting their identity, and it will be their strength." This pride in his culture and language guided his teaching and mentorship, and he served as a cultural translator and advocate for his community. Museums, anthropologists, and government agencies often called upon Paul for his expertise, and he was part of a group that traveled to museums around the world during the 1990s to examine objects that originated in the Yukon–Kuskokwim Delta.

In 1977, Paul spent ten days working with a group of Yup'ik students at Nelson Island High School in southwest Alaska, telling stories and sharing lessons learned throughout his life. In 2003, the University of Washington Press published his speeches and stories from this residency in a bilingual Yup'ik and English book called *Stories for Future Generations/ Qulirat Qanemcit-llu Kinguvarcimalriit*, which has become a widely read and cited work about Yup'ik culture. He has also published several books in the Yup'ik language and taught, composed, and shared Yup'ik songs, dances, and stories to audiences large and small. For his teaching and deep cultural knowledge, he earned an honorary doctorate from the University of Alaska Fairbanks in 2010. He died in 2015 at the age of eighty-five, leaving behind a legacy of cultural revitalization, language revitalization, mentorship, advocacy, and more.

MARIA TALLCHIEF

Osage

1925–2013 • PRIMA BALLERINA

The first Indigenous prima ballerina, Maria Tallchief, broke barriers in the world of ballet, not only for Native people, but also for Americans in general by joining Russian-led and European dance companies that had previously been closed to Americans. Born Elizabeth Marie Tallchief in Fairfax, Oklahoma, Maria and her sister Marjorie began dancing at a young age, encouraged by their mother, who had grown up poor and didn't have the opportunity to take dance classes. When Maria was a preteen, the family moved to Los Angeles, hoping to find opportunities for her and Marjorie in the entertainment industry. Then, at the age of seventeen, Maria moved to New York City to pursue her dream of ballet. Early in her career, she was encouraged to change her last name, which was recognizably Indigenous, to something more "Russian sounding" to increase her chances for success and to reduce the discrimination she might face, but she refused to change it. Maria was proud of her heritage, and throughout her career, she used her platform to speak out about the misconceptions and stereotypes of Native people.

Starting as a member of the corps de ballet in the Ballet Russe de Monte-Carlo, Maria quickly moved up in the ranks and caught the eye of top dance critics. When famed choreographer George Balanchine went to work with the Ballet Russe, he was struck by Maria's talent. George and Maria later fell in love and in 1946 they got married and moved to Paris. They worked for the Paris Opera Ballet, and Maria became the first American dancer to debut with the troupe. After Paris, George founded the Balanchine Ballet Society, which later became the New York City Ballet (NYCB), and Maria was named a prima ballerina—the first American to achieve the title. She held the position of prima ballerina with the NYCB for eighteen years and was known for her famed roles like Stravinsky's Firebird and the Sugar Plum Fairy in *The Nutcracker*. Maria and George split up in 1952, but she stayed with the NYCB until her retirement from dancing in 1965.

After her retirement, Maria, together with her sister, went on to found the Chicago City Ballet in 1980, where she served as its creative director until 1987. Throughout her life and career, she was recognized with many awards and honors. In 1996, she was admitted to the National Women's Hall of Fame and received Kennedy Center Honors for her artistic contributions to the United States. In 1999, she received the National Medal of Arts, which is the highest award the U.S. government gives to artists. After a long and illustrious career, Maria passed away in 2013 at the age of eighty-eight. The Osage community honored her with the name Wa-Xthe-Thomba, which means Woman of Two Worlds, to commemorate her achievements in the world of ballet and as an Osage woman.

STERLIN HARJO

Seminole, Muscogee Creek

1979– • FILMMAKER

Sterlin Harjo has been pushing for Native representation in film for his entire career, wanting to share and showcase the diversity of Indian Country—the hilarious, the hard, the beautiful, and the heartbreaking, but above all the real and the true. Sterlin feels that the current system in Hollywood has failed Natives, and so it's time for Natives to represent themselves. He says, "It's not up to Hollywood to change Native representation in the media. They have failed at it for decades. It's up to us—artists, filmmakers, storytellers, and activists. That power is ours alone."

Born in Holdenville, Oklahoma, Sterlin has made three feature-length films and two feature-length documentaries, as well as numerous short films and documentaries. Several of his films have premiered at the Sundance Film Festival, imagineNATIVE Film and Media Arts Festival, and the American Indian Film Festival. Sterlin's 2020 documentary *Love and Fury* follows a diverse group of Native artists through their day-to-day lives, demonstrating the challenges and complexities of navigating an art world dominated by non-Native conceptions of what Native art and identity "should" be. His director's note states: "I wanted to make something bold and in your face, directly putting up a finger to the shackles of the art world and historic representation of our people. We are diverse, we are dark, we are beautiful, and so is our artwork."

Additionally, Sterlin is a founding member of the Native sketch comedy group The 1491s and hosts a podcast called *The Cuts with Sterlin Harjo.* He was also a director for *Osiyo, Voices of the Cherokee People*, the Cherokee Nation's award-winning monthly television news magazine, which is shown on networks nationwide. In 2020, he began filming *Reservation Dogs,* a TV series for FX that he co-created with Maori actor and filmmaker Taika Waititi and is about a group of Native teenagers growing up in Oklahoma. He says, of his partnership with Taika, "As longtime friends, it was only natural that Taika and I found a project together, and what better than a show that celebrates the complementary storytelling styles of our Indigenous communities—mine in Oklahoma and Taika's in Aotearoa." The pilot, which Sterlin and Taika co-wrote and Sterlin directed, was casted and filmed locally in Oklahoma. The show was picked up for a full series to debut in 2021, and is the first mainstream TV series written, directed, and produced by Indigenous people, a huge win for Native representation in television.

REPRESENTATION MATTERS

The Land O'Lakes butter logo, the Jeep Grand Cherokee name, Indian warrior Halloween costumes, hipster headdresses at Coachella, play tipis at Target, Dior Sauvage perfume ads, and, yes, Indian mascots like the Washington Redsk*ns . . . everywhere you look in the United States, you are surrounded by images and representations of Native people. Most of these images are stereotypical, created by non-Natives, and are harmful. They often reduce the incredible diversity of Native people into a series of one-dimensional stereotypes, set in the historic past, or depicted as fantasy creatures, placed next to wizards and fairies. Cultural appropriation is a buzzword that has become shorthand for this cultural theft and misrepresentation, and it means taking something from a marginalized culture that is not your own, without permission, and erasing the cultural context and structure from which it comes.

But why do these misrepresentations matter? There is an abundance of psychological research that demonstrates these stereotypes are not only harmful to the self-esteem and well-being of Native youth, but they also continue the process of colonization. In order to justify the genocide waged against Native people, we must continuously be painted as inferior—unworthy of our lands and our lives—and these images contribute to that. Native and non-Native people are taught—explicitly in classrooms and implicitly through messages from the media—that Native cultures are something of the past, something that exist in negative contrast to Western values, and something that anyone can commodify and appropriate. Because of this, our contemporary existence (and therefore the real challenges in Indian Country) are often ignored in the minds of the dominant culture.

How can we expect mainstream support for our sovereignty, self-determination, nation building, and tribally controlled education, health care, and jobs when the majority of Americans view Native people only as stereotypes, situated in the historic past, or even worse, situated in their imaginations? We can't, and that is why representation matters.

Luckily, we are in a moment where Native media is being produced at a rapid rate, and it's much easier to find and support Native-created and -authored content—like the Cherokee Nation's award-winning TV show *Osiyo*, the movies directed by Native filmmakers like Sterlin Harjo (page 79), or the books by writers like Brandon Hobson, Terese Mailhot, Elissa Washuta, Tommy Orange (page 35), and others. Native artists like Jared Yazzie, Jamie Okuma (page 119), and hundreds more are creating fashion that celebrates real Native design. Anytime you buy from or support a Native artist, you're sending a message that you want to see true representation of Native cultures, and that is powerful.

PO'PAY

Ohkay Owingeh Pueblo

C. 1630–1688 • MEDICINE MAN
AND PUEBLO REVOLT LEADER

In 1680, the Pueblo communities of what is now northern New Mexico staged a successful rebellion against Spanish occupation. Pueblo scholars call this the first successful revolution against a foreign colonial power in what is currently known as North America. The Pueblo Revolt, as it came to be called, was led by an Ohkay Owingeh medicine man named Po'Pay. Not much is known about Po'Pay's early life, but in 1675, he and forty-seven other Pueblo men were accused of "sorcery" and arrested for practicing their traditional religion. Four men were sentenced to be hanged, while the others were sentenced to imprisonment. Delegates of the Pueblo people traveled to Santa Fe to protest the rulings, and under the threat of war, the Spanish released Po'Pay and the other men. However, the Spanish told the Pueblo people they could no longer practice their traditional spirituality and must adopt Christianity.

Amid this harsh suppression of Pueblo lifeways by Spanish colonizers, Po'Pay emerged as a leader and began planning a rebellion. He met with other war captains at Taos Pueblo, and they hatched a plan for a coordinated attack against the Spanish occupiers across the twenty-four communities. These pueblos were spread out across nearly four hundred miles of desert, spoke six different languages, and prior to this movement would not have considered themselves to be a united "pueblo" people. Since the Spanish prohibited the Pueblo's use of horses, Po'Pay sent runners to the communities on foot, each with a knotted yucca rope. A knot was to be untied each day, counting down until the day of the revolt. When sympathizers informed the Spanish of the plan, the revolt was moved forward by two days, to August 10, 1680, catching the Spanish by surprise. After a bloody battle, the Spanish were driven out of Pueblo communities, and the Pueblo people were free to practice their traditional ways of life for the next twelve years. Today, Po'Pay is celebrated as a hero throughout Pueblo communities, and he is recognized for saving Pueblo cultural ceremonies and practices from extinction during Spanish colonization.

JAMES LUNA

Luiseño, Kumeyaay

1950–2018 • PERFORMANCE ARTIST

James Luna was a force in the world of performance art. Using humor, irony, and playing with stereotypes and preconceived notions about Native people, James created interactive and thought-provoking pieces that challenged museum and gallery visitors to rethink their assumptions. Born in 1950 in Orange, California, he moved to the La Jolla Indian Reservation in 1975, where he worked for the tribe and was an active member of the community, documenting it through his photography and writing. He earned a Bachelor of Fine Arts degree from the University of California Irvine in 1976 and a master's degree in counseling from San Diego State University in 1983.

To James, art was the way to question and examine Native identity, the role of museums in colonization, and more. He started as a painter but later moved to performance and installation art. In one of his most well-known pieces, *The Artifact Piece* (1987), James put himself into a museum display case at the San Diego Museum of Man (now called the Museum of Us), lying on a bed of sand wearing a breechcloth. The accompanying labels on and in the case pointed to distinguishing features, like scars earned from fishing and fighting. The piece challenged viewers to question the ways Native people are objectified in museums. He said, "I had long looked at representation of our people in museums, and they all dwelled in the past. They were one-sided. We were simply objects among bones, bones among objects, and then signed and sealed with a date. In that framework, you really couldn't talk about joy, intelligence, humor, or anything that I know makes up our people."

In addition to continuously creating art, James also taught art at the University of California San Diego and served as an academic counselor at a community college for twenty-five years. He was a lifelong advocate for Native achievement through education. James passed away in 2018, leaving behind a legacy of radical, disruptive, funny, poignant, and groundbreaking work for a generation of Native artists to follow. In all, James participated in over fifty-eight solo exhibitions and many other group collaborations spanning three decades at museums and in spaces all over the world.

HOLLY MITITQUQ NORDLUM

Inupiaq

C. 1970– • TRADITIONAL TATTOO ARTIST

Holly Mititquq Nordlum was born and raised outside the village of Qikiqtaġruk (Kotzebue), Alaska. She now lives in Anchorage and is working to revive traditional Inuit tattooing practices. Tattoos have been part of Inuit culture for millennia and are traditionally given to women, by women, on the face and body to mark important milestones. These tattoos were once a normal and important part of a woman's life, but they were outlawed by white settlers and had not been commonplace for about a hundred years when Holly began to study and revive the practice in 2015. Inspired by her great-grandmother, who was the last woman in her family to have traditional tattoos, she got a grant from the Anchorage Museum to learn the art. Holly was unable to find anyone in the Anchorage area who still practiced traditional tattooing, so she studied with an Inuit artist in Greenland, who taught her the stick-and-poke and skin-stitching methods that don't use any machines or modern techniques. After mastering the art form, Holly created a program called Tupik Mi (Tattoo People) to train other artists, and she travels around Alaska and the world teaching about the importance of Inuit tattooing. Receiving traditional tattoos from artists like Holly is a way for Inuit women to reconnect with their ancestors, heal, and express pride in their identity. The tattoo process is often an emotional one for both Holly and her clients, as they share their stories and reconnect with their heritage. In her words: "Something about poking the skin opens up emotional doors."

In addition to her tattoo work, Holly is a multi-talented and successful printmaker, painter, filmmaker, sculptor, and graphic designer who uses these mediums to "express ideas about life and social issues of Native people in today's world." All of her creative work centers on her pride in Native identity. She says, "I wanted to do something for my own community. I'd been thinking a long time about how to reach younger people, how to make them aware and proud of who they are. . . . This is about healing—healing from colonization."

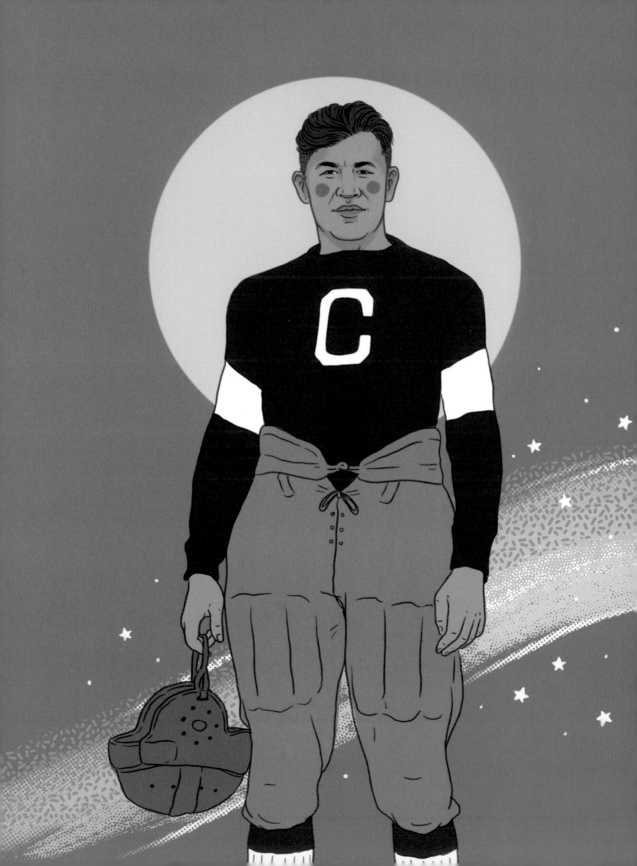

JIM THORPE

Sac and Fox

1887–1953 • ATHLETE

Jim Thorpe, who was considered one of the most talented athletes in the world, defied odds, set records, and broke barriers for Native athletes. Born in 1888 in Indian Territory, later Oklahoma, Jim was raised in his Sac and Fox community and given the name Wa-Tho-Huk (Bright Path). He attended the Carlisle Indian Industrial School in Pennsylvania, a government-run boarding school for Native children meant to assimilate them into "mainstream" society and sever their connection to their Native identity. While he was an underclassman at Carlisle, he watched the upperclassmen practicing the high jump and thought he'd give it a try, even though he was wearing overalls instead of athletic clothes. He managed to clear a bar taller than he was—an early indicator of his natural athletic ability. He played football and ran track and field for Carlisle and then for the Haskell Indian Nations University; eventually, the famed football coach Pop Warner took notice of his talent, and became his coach and mentor in 1911.

In 1912, he competed for the U.S. Track and Field Team at the Summer Olympics in Stockholm, where he won medals in many of his events. Shortly before his fifteen hundred–meter run for the decathlon, his shoes went missing, presumably stolen. Pop Warner, who had accompanied Jim as supporter and coach, found him a replacement pair of shoes, but they were mismatched and ill-fitting. Despite the shoes, Jim went on to win the decathlon. He took home two Olympic gold medals—for decathlon and pentathlon—making him the first American to do so and the first Native athlete to win an Olympic gold medal. His performance was so impressive that many of his records weren't beaten until many years later. However, in 1913, the Amateur Athletic Union stripped him of his medals after an investigation, which discovered that he had played semi-professional baseball in 1909 and 1910, disqualifying him from Olympic competition. Many athletes, fans, and community members felt this was unjust, and after decades of pressure, the International Olympic Committee presented his family with replica medals in 1982, but the official Olympic record has never been corrected. In anticipation of a movie about his life, there are renewed efforts to restore his medals properly. Following the Olympics, he went on to play professional football, basketball, and baseball, and in 1950, a group of sportswriters selected him as the greatest American athlete of the first half of the twentieth century.

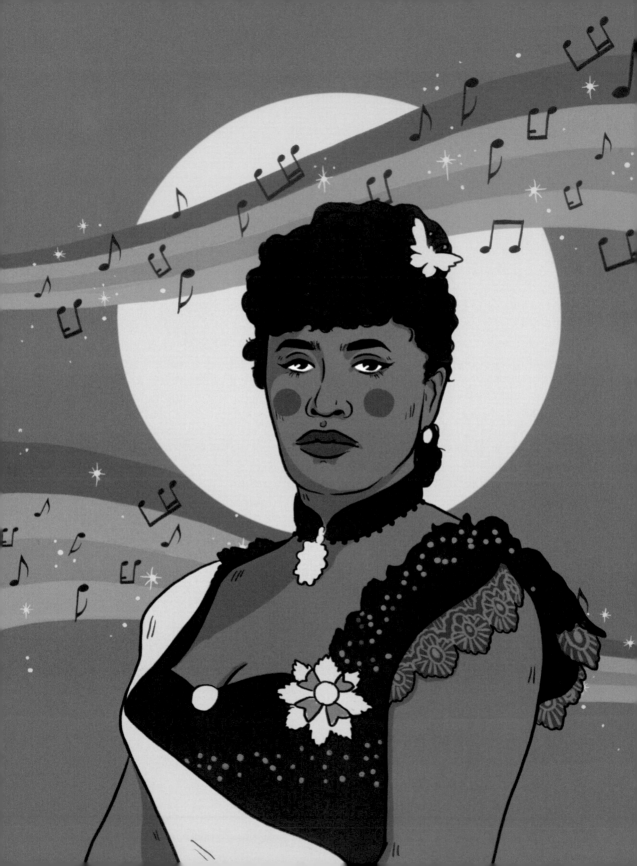

LILI'UOKALANI

Kanaka Maoli

1838–1917 • HAWAIIAN MONARCH

Queen Lili'uokalani, born Lydia Lili'u Loloku Walania Wewehi Kamaka'eha, was the last sovereign monarch of the Hawaiian Kingdom, before the United States illegally overthrew the monarchy and subsequently annexed Hawai'i. She was born to a high-status Hawaiian family, and her mother was an advisor to King Kamehameha III. She acceded to the throne after the death of her brother King David Kalākaua in 1891, taking her royal name of Lili'uokalani and becoming the first woman to rule Hawai'i.

In 1887, an armed militia forced King Kalākaua to sign a new constitution that reduced the monarchy's powers, and when Lili'uokalani took over the throne, she sought to restore many of those powers. In response, in 1893, a group of American and European plantation owners and businessmen in Hawai'i initiated a coup, which stripped the monarchy of any remaining authority. They installed a provisional government made up of their own leaders and allies, charged Lili'uokalani with treason, and imprisoned her under house arrest for over two years. In 1895, after she was forced to abdicate the throne and was released, she traveled to Washington, D.C., to fight for the sovereignty of the Hawaiian Kingdom.

Although she was ultimately unsuccessful in getting justice for her people, Lili'uokalani was a leader of the Stand Firm ('Onipa'a) movement and fought for three years to prevent the U.S. annexation of Hawai'i. Unfortunately, the United States moved forward with annexation in 1898, despite the fact that the U.S. Congress never passed a treaty. Lili'uokalani subsequently withdrew from public life but never gave up her love of her nation, saying, "The cause of Hawai'i and independence is larger and dearer than the life of any man connected with it. Love of country is deep seated in the breast of every Hawaiian, whatever his station."

In addition to her political work, Lili'uokalani was a prolific musician and composer throughout her life, composing over 160 chants and songs, including the famous "Aloha 'Oe." She passed away in 1917 at the age of seventy-nine and is loved and remembered as a powerful leader and hero to the Hawaiian people.

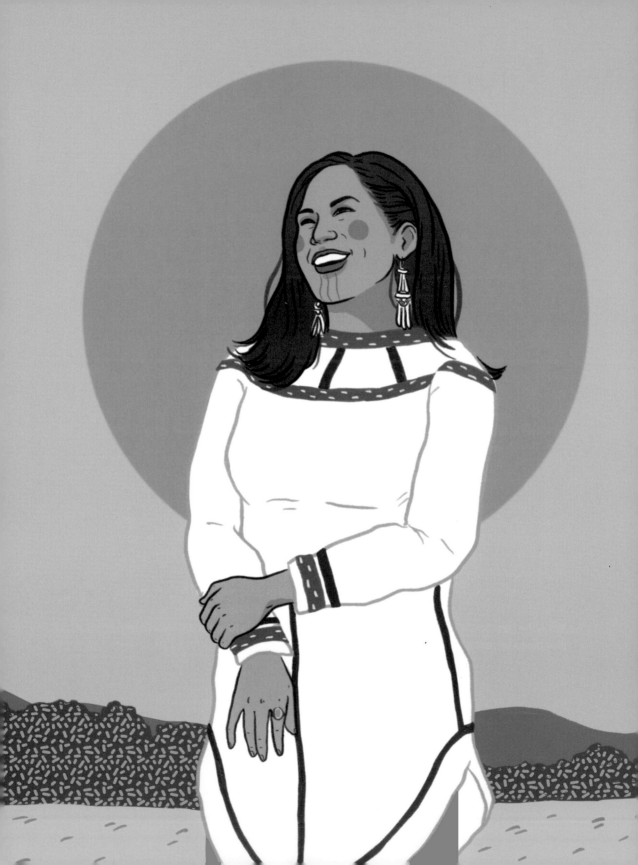

PRINCESS DAAZHRAII JOHNSON

Neets'aii Gwich'in

1974– • ENVIRONMENTAL ORGANIZER AND ACTIVIST, PRODUCER, AND FILMMAKER

Princess Daazhraii Johnson has been using storytelling—through poetry, acting, essays, and filmmaking—for the protection of the lands, waters, and Native ways of life in Alaska for most of her life. One of the founding members of the Fairbanks Climate Action Coalition (FCAC), she and her organization have worked tirelessly to prevent oil drilling in the caribou birthing grounds of the Alaska Native Wildlife Refuge. Her people, the Gwich'in, call the Arctic home, and they rely on the Porcupine caribou for subsistence living. The elders of her community taught them that their relationship with the caribou was sacred, and that they would not be able to survive if the birthing grounds of the Porcupine caribou were not protected. Through her work with FCAC and other environmental advocacy groups, Princess has worked alongside many others to organize protests and education campaigns aimed at shifting the narrative at the local, state, national, and international levels to fight for Indigenous human rights as they relate to climate change and to stop legislation that would grant drilling permits.

Princess grew up all over the United States and often faced discrimination for her Gwich'in identity—she saw how most Americans held deep stereotypes of Indigenous people and Alaska Natives in particular. Through these experiences, she began to understand the power of representation in the media and saw film and TV as a space to break stereotypes and to share culture. She now works hard to increase the representation of Native people in the arts—she is a Sundance fellow and an actress, serves on the boards of various arts organizations, and in 2015, President Obama named her as a trustee for the Institute of American Indian Arts. She is also the creative producer of an animated PBS children's show, *Molly of Denali*, about a young Alaska Native girl. The show follows Molly and her family, friends, and community, and it teaches preschool-age children life lessons as well as culturally grounded, contemporary stories of Alaska Native life. It is the first PBS show to feature a Native protagonist, stars Native voice actors, and is made by a team that includes many Native crew members. The show is revolutionary in its representation, and, as Princess says, "These stories contain our values and that's something the world needs. I'd like to inspire the next generation to continually ask questions and examine their own cultural stories, the ones that have shaped who they are and honor where they've come from."

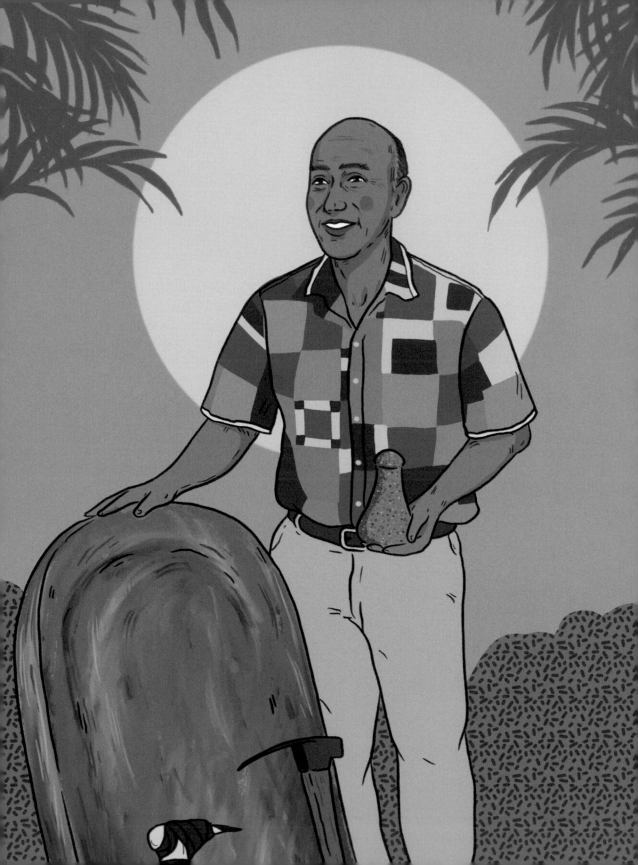

EARL KAWAʻA

Kanaka Maoli

1945– • CULTURE KEEPER

Earl Kawaʻa grew up in rural Halawa Valley, Molokaʻi, on a kalo (taro) farm. People in his community regularly pounded their own kalo to make poi (a traditional staple Hawaiian food), using traditional wooden boards and stone pounders. In 2006, after many years of living and working away from Molokaʻi, Earl was asked to return to the island to teach poi pounding. When he could only find one board and two pounders on the whole island, he realized that this cultural practice was being lost, and he made it his mission to teach it to as many Kānaka Maoli as possible. He began offering workshops on making the papa kuʻi ʻai (poi board) and pōhaku kuʻi ʻai (stone poi pounder) and coined the phrase "a board and stone in every home." One of the few first-language native speakers of ʻŌlelo Hawaiʻi (Hawaiian language) still alive in Hawaiʻi, Earl uses his workshops as an entry point to teach the Hawaiian language and cultural protocols as well as traditional skills and knowledge.

Earl has taught thousands of students of all ages. He sees his teaching as something that strengthens families, who often attend his workshops together to make the family poi board and pounder. As he instructs his students on the process, he also shares traditional knowledge and teachings that connect his students to their heritage and to each other. "Whatever concept I talk about, there is a driving principle. It's not about what I think, it's what I know and what's handed down to me," he says. "My opinions don't count. It's ancestral knowledge that counts, and I'm the keeper of that knowledge and the teacher of that knowledge." In 2019, the Honpa Hongwanji Mission of Hawaiʻi named Earl a Hawaiʻi Living Treasure and recognized him for his role as an "educator, peacemaker, and Kanaka leader." Now, in his late seventies, he works as a Hawaiian resource specialist for Kamehameha Schools, the system of schools in Hawaiʻi for Native Hawaiian students, and he continues to work toward his goal of "a board and stone in every home."

HAWAI'I AND ALASKA

While the story of settler colonialism in Hawai'i and Alaska shares much with the experiences of Indigenous people in the continental United States—outsider arrival, death due to disease and conflict, forced assimilation, cultural genocide, and more—it also looks and feels different in many ways. Timelines, policies, and current conditions make the experiences of Kānaka Maoli and Alaska Native people unique. Additionally, both Hawai'i and Alaska have a long and ongoing relationship with a U.S. military presence because of their "strategic" geographic locations.

HAWAI'I

Kānaka Maoli, the only Indigenous culture of Hawai'i, had no sustained contact with Europeans until Captain James Cook arrived in the Hawaiian Islands in 1778. Shortly thereafter, Protestant missionaries from the United States began to arrive and Americans began seizing the opportunity to grow sugarcane in Hawai'i's warm climate. With the establishment of sugar plantations, large numbers of laborers came to the islands from Asia. In 1896, 25 percent of Hawai'i's population was Japanese, due in part to assistance, special provisions, and protections from Japan's government for those who emigrated. Disease and colonization meant the Kanaka Maoli population was reduced from three hundred thousand to only twenty-four thousand by 1920. Despite the dramatic loss of life and Hawaiian cultural practices, the Kingdom of Hawai'i prevailed as a recognized sovereign nation, with new arrivals from Asia and the United States beholden to Hawaiian laws and customs. Powerful non-Native landowners challenged these laws, and in 1887, they forced King Kalākaua to sign a new constitution that stripped him of many of his powers and diminished the rights of Indigenous Hawaiians.

The Hawaiian monarchy was illegally overthrown in 1893, and the United States annexed Hawai'i as a U.S. territory in 1898, despite massive protests, petitions, and international outrage. Hawai'i formally became a state in August 1959, the end of a decades-long, drawn-out process. As a territory, it was easier for white plantation owners to maintain power, and they resisted statehood. But nonwhite Hawaiian settlers and some

Native Hawaiians wanted the rights and protections that accompanied statehood. With the addition of Alaska as a state in January 1959, President Eisenhower agreed to Hawaiian statehood to maintain a political balance in the U.S. Senate. In 1993, the U.S. government passed what became known as an Apology Resolution, which apologized "to Native Hawaiians on behalf of the people of the United States for the overthrow of the Kingdom of Hawai'i on January 17, 1893 . . . and the deprivation of the rights of Native Hawaiians to self-determination." Many Kānaka Maoli felt it was a hollow attempt to appease sovereignty advocates and did little to change things, while others felt it was documented proof the overthrow was illegal and could be used on an international stage to continue the sovereignty fight.

Unlike the federally recognized tribes in the continental United States, Kānaka Maoli do not have a recognized status as a "tribal nation," and there is no formal relationship between Kānaka Maoli and the Bureau of Indian Affairs. In 2000, U.S. Senator Daniel Akaka of Hawai'i introduced the Akaka Bill, which would have classified Kānaka Maoli as a federally recognized tribe, while also limiting its ability to pursue tribal gaming, participate in programs, receive the same resources as American Indians (such as Indian Health Services), or to pursue legal action against the United States over past wrongs. Many in the Hawaiian sovereignty movement argue that the United States has no right to regulate anything to do with Kānaka Maoli because it is illegally occupying the Kingdom of Hawai'i. Because of such opposition, the bill has never passed, leaving Kānaka Maoli in a unique relationship with the U.S. government.

ALASKA

Alaska Native people first experienced contact with Russian fur traders in the 1770s, and a decade later, Russian Orthodox Christian missionaries established a large presence in Alaska. Russian settlers and traders continued to colonize the region through the mid-1800s, and in 1867, Russia "sold" Alaska to the United States for $7.2 million (equivalent to about $132 million today), and it became a U.S. territory—a fact that was unknown to many Native people. At the time, many opponents in the United States argued that this was a waste of funds and that there wasn't "value" to the lands other than limited national defense benefits.

The United States paid little attention to the territory until the discovery of gold in 1899 that brought a huge influx of American settlers to the region. Over the next hundred-plus years, commercial fishing, gold mining, and oil drilling stripped Alaska of

much of its natural resources, wreaking environmental havoc and disrupting thousands of years of subsistence living for Alaska Native people. During the early days of the Cold War, concerns about the territory's proximity to Russia held back statehood movements, as did concerns about the amount of federal land that would be transferred to a state government. But in 1959, supported by President Eisenhower, Alaska became the forty-ninth state.

In 1971, spurred by the discovery of oil in 1968, the United States passed the Alaska Native Claims Settlement Act, which was designed to compensate Alaska Native people for land taken by the United States. It established thirteen regional for-profit corporations and over two hundred village corporations to manage forty-four million acres (approximately 10 percent of the total lands of Alaska) and $962.5 million. This meant that those Alaska Native people who were born before 1971 and who registered in time became "shareholders" in their regional and/or village corporations. Each shareholder was given a set number of shares in their corporation that entitled them to receive dividends from extractive industries. These shares cannot be sold but may be divided and passed to descendants. This new approach to federal Native policy has meant that the extraction of natural resources in Alaska can continue largely unabated in the lands not parceled out under the act and controlled by the corporations. The Metlakatla Indian Community, a community of Tsimshian who relocated to Alaska from British Columbia in 1897, was the only community to refuse the terms of the act, so their land is treated as an Indian reservation like those in the Lower 48.

All Alaska Native people are, unlike Kānaka Maoli, treated as "Indians" under U.S. policy, meaning they can access any resources or rights reserved for Native Americans. The act also means that in addition to a cultural, village, clan, or other Native affiliation, Alaska Native folks also have a regional corporation and village corporation as part of their affiliation. There are mixed feelings among Alaska Native people as to the effectiveness of this system. Some critique its heavy ties to capitalism and Western business structures; others feel it allows Alaska Native communities more control over their lands and resources than they would have been allowed under other models.

There are ten distinct Indigenous cultural groups in Alaska: Inupiaq, Yup'ik, Cup'ik, Athabascan, Aleut, Alutiiq, Tlingit, Tsimshian, Haida, and Eyak. Among them, there are twenty different Indigenous languages spoken and 231 federally recognized "tribal entities" (also referred to as villages), which are treated as tribes under the Bureau of Indian Affairs. Despite this, the vast cultural diversity of Alaska is often lost and collapsed into "Eskimo" stereotypes of igloos and sled dogs. The term Eskimo is considered offensive by many Alaska Natives, who prefer to be called by their proper cultural group name.

Many of the current issues for Alaska Native communities focus on climate, environment, and public health. Because villages are often isolated and rural, making it difficult to transport western conveniences like fresh groceries or medical supplies, subsistence hunting and fishing are what allow communities to survive—but climate change, overfishing and hunting by non-Natives, development, and extractive industries threaten the land and water animals Native people depend on for food. Alaska Native communities are often the first to be hit by climate change in tangible ways, with villages becoming uninhabitable due to sea level rise and melting permafrost, meaning that what happens to rural Alaska communities is a sign of what is to come for many communities throughout the world.

ESTHER MARTINEZ

Ohkay Owingeh Pueblo

1912–2006 • LINGUIST AND STORYTELLER

Thanks to the tireless work of Indigenous language revitalization advocate Esther Martinez, also known as P'oe Tsáwä (Blue Water), an entire generation of Native youth is able to learn their languages in their public schools, and thousands of Tewa-speaking communities have access to educational materials in their language.

Esther, known lovingly by many as Ko'oe (Aunt) Esther, was born on Ohkay Owingeh Pueblo in New Mexico. She was sent to a government-run boarding school for her education, where she graduated in 1930. During her time in boarding school, she, like many other Native children at the time, was punished for speaking her native Tewa language. Despite the attempts to force her to abandon her Native language for English, Esther held onto her language. While working at the John F. Kennedy Middle School in Ohkay Owingeh Pueblo in the 1960s, the community asked her to help document the Tewa language. She worked to develop the first Tewa dictionary, which has since been revised to reflect different dialects and is used in other Tewa-speaking villages. She also translated the New Testament into Tewa.

In addition to her linguistic work, she was also a renowned storyteller. She wrote children's books reflective of Pueblo culture and stories, and in 2004, she published a memoir *My Life in San Juan Pueblo: Stories of Esther Martinez*, with memories from her youth and traditional stories from her community. Through her work with Storytellers International, she traveled all over the United States and the world, telling stories about her life and her people. She saw stories as opportunities for teaching and learning. She said, "Indian people get their lessons from stories they were told as children. So, a lot of our stories are learning experiences."

In 2006, the year Esther passed away at age ninety-four, the National Endowment for the Arts honored her as a National Heritage Fellow for folk and traditional arts. In that same year, the Esther Martinez Native American Languages Preservation Act was signed into law. The act amended the Native American Programs Act of 1974 to expand funding for language immersion programs, where students are taught in their Native language for the majority of the school day.

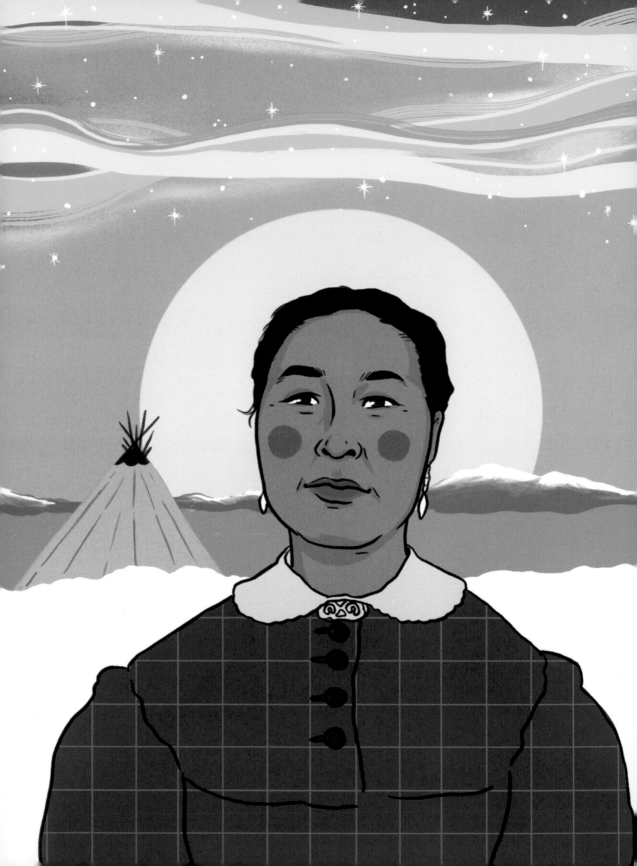

TAQULITTUQ

Inuk

1838–1876 • GUIDE AND INTERPRETER

Taqulittuq was an Inuk interpreter and guide, who accompanied many well-known exhibitions by non-Native "explorers" throughout the Arctic in the mid-1800s. She was born in the Qikiqtaaluk Region of what is now known as Nunavut, Canada, to a family of travelers. In 1853, when she was a young woman, a whaling captain brought her and her husband, Ipirvik, to England to be exhibited as a curiosity to the English elite. They met and dined with Queen Victoria and were eventually returned to the Arctic. When, in 1860, the explorer Charles Francis Hall was looking for guides for his journey to search for the lost Franklin expedition, which had disappeared in 1845, he hired Taqulittuq and Ipirvik. They accompanied him on the journey, which was unsuccessful, and afterward traveled with him on his lecture tours.

Taqulittuq and Ipirvik lost their young son to pneumonia after a set of exhibitions in New York and lectures on the East Coast. Despite her grief, she agreed to accompany Hall on another Arctic expedition and gave birth to a baby boy while on the journey. Tragically, he died as an infant, but Taqulittuq and Ipirvik later adopted a little girl, whom they called Panik (daughter). She accompanied them on the rest of their expeditions.

In 1871, the U.S. government tasked Hall to try and reach the North Pole on an expedition aboard the *Polaris,* and Taqulittuq and Ipirvik again served as his guides and interpreters. Hall died on the journey, possibly from poisoning. On the return voyage, a group of expedition members, including the Inuk guides, were separated from the ship and trapped on a drifting ice floe for six months. They survived because of the Indigenous knowledge of Taqulittuq and Ipirvik, who knew how to survive in Arctic conditions and were able to hunt and fish on the ice to feed the remaining crew. A sealer rescued them in 1873.

After the *Polaris* expedition, Ipirvik continued to work as a guide, while Taqulittuq and Panik moved to Connecticut. Their time on the ice floe had been hard on Panik, whose health never fully recovered, and she passed away at age nine. Taqulittuq died soon after, at age thirty-eight, her death partially attributed to heartbreak. Without a doubt, the successes and "discoveries" of the non-Native explorers in the Arctic would never have been possible without the knowledge and guidance of Taqulittuq, who helped them navigate, survive, and communicate with Inuit in the region.

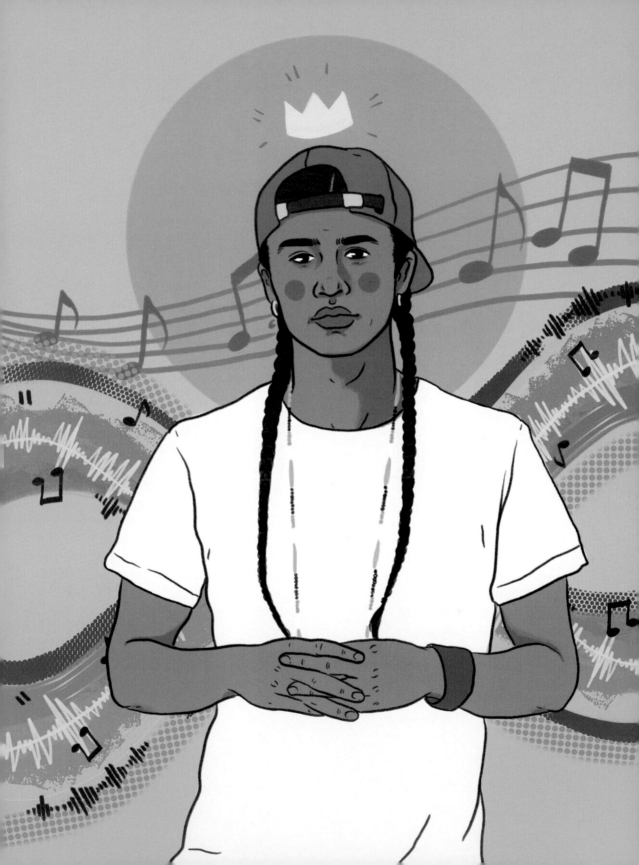

FRANK WALN

Sicangu Lakota

1989– • MUSICIAN, RAPPER,
AND COMMUNITY ADVOCATE

Through his music and community advocacy, Lakota rapper and musician Frank Waln brings attention not only to the ways Native people continue to be mistreated and harmed by colonization but also to the power and resilience of Indigenous people. Born and raised on the Rosebud Indian Reservation in South Dakota, Frank made music and recorded in his home studio from the time he was a young teenager. He went to college, originally intending to become a doctor, but he ultimately realized that his heart was in music. He graduated from Columbia College Chicago with a degree in audio arts and acoustics and has been a working musician ever since.

Frank makes his own beats for his hip-hop and is also an accomplished Native flutist. He released his first two solo albums in 2017 and an album of original flute tracks, *Olówaŋ Wétu* (*Spring Songs*), in 2020. He says about his music, "I started making music because it made me feel good. It was how I made sense of the world, how I dealt with the world, how I dealt with my issues. I was just talking about my life, my lived experience, and to the nature of Indigenous people—our reality being shaped so much by government policy. My music became political whether I wanted it to or not, just because I was talking about my life and the history of my tribe."

Themes of stereotypes, mental health, environmental justice, family, and homelands run through Frank's work, such as the song "What Makes the Red Man Red," which remixes the harmful song of the same name from Disney's *Peter Pan* or "My Stone," a song dedicated to his single mother. As an independent artist, he is committed to working with Native producers, filmmakers, photographers, designers, and communities in producing his work, and he spends much of his time traveling throughout Indian Country, offering his story and words of empowerment to Native youth and at community gatherings.

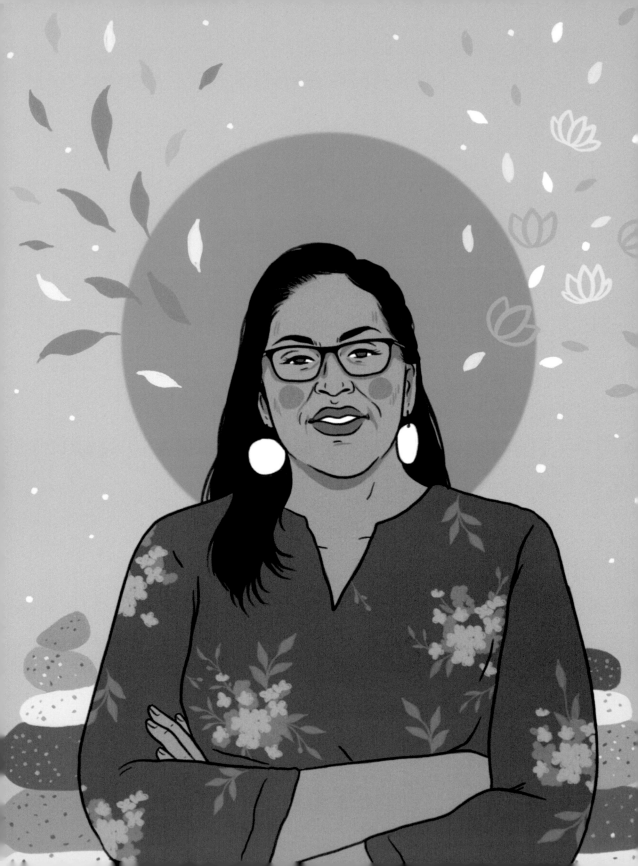

TWYLA BAKER

Mandan, Hidatsa, Arikara

1976– • COLLEGE PRESIDENT

Twyla Baker grew up on the Fort Berthold Reservation in North Dakota. Although she loved her homelands and her community, she left the reservation to attend college and grad school, with the goal of making things better for Native people and using research as a tool for positive change. She earned her bachelor's degree in environmental geology and technology, a master's degree in education, and a PhD in research methodology and quantitative methods, all from the University of North Dakota, but her goal was always to return home to her community.

In 2013, she accepted a job in student services at Nueta Hidatsa Sahnish College, which is one of the thirty-seven tribal colleges and universities. These schools developed because mainstream colleges and universities historically were not equipped to meet the complex needs of Native students and tribal nations. Viewed through a culturally grounded lens, tribal campuses are able to offer the coursework and resources Native communities need. Within just a year of Twyla's arrival on campus, she was named president of the college.

Twyla sees herself not as a college president who happens to be a community member but as a community member who happens to be a college president, putting her role as a tribal community member first in all of her work. While a third of tribal college presidents are women, Twyla is the only one with a STEM (science, technology, engineering, and mathematics) degree. She is a strong advocate for bringing more Native people into STEM fields, serving on the board of the American Indian Science and Engineering Society, mentoring students and faculty, and demonstrating that Indigenous knowledge is not in conflict with Western science.

Twyla is a mother to seven children and fills the role of Native auntie to her thousands of followers on social media by providing daily support, words of affirmation, and thoughts on ancestors, culture, and family. She believes that "someday in the future, our descendants may talk about our brief run-in with capitalism and colonialism as another blip in our history. Like Ice Ages, disease, wars, and migrations. We'll tell it as another part of our oral history, because Indigenous people will still be here."

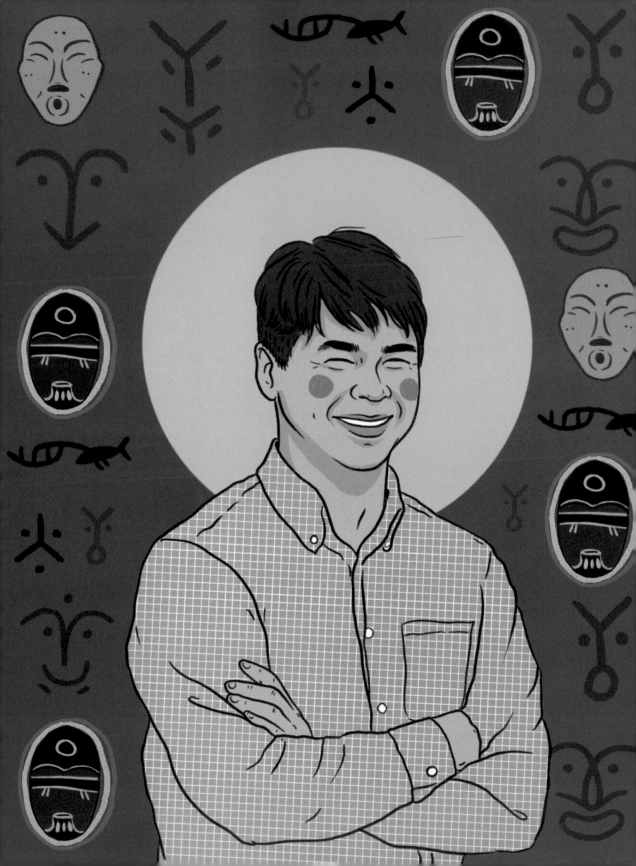

SVEN HAAKANSON JR.

Sugpiaq (Alutiiq)

1966– • SCHOLAR AND CURATOR

At the time Sven Haakanson Jr. was growing up in a small village in Bar Harbor, Alaska, his community had been experiencing colonization for hundreds of years, as some of the first Alaska Native people contacted by outsiders in the 1780s. As a result of forced assimilation and cultural loss due to colonialism, many in his community were unable to teach him anything about being Sugpiaq. But one elder noticed Sven's interest and taught him the Sugpiaq language and many cultural practices. Because of these early experiences, Sven has dedicated his life to the revitalization of Sugpiaq language and culture. He eventually found his way to the University of Alaska Fairbanks to study English before earning a PhD in anthropology from Harvard University.

From 2000 to 2013, he was the director of the Alutiiq Museum on Kodiak Island, which is both a traditional museum and a cultural research hub that performs language documentation, archaeological digs, and community work. The museum also serves as a traveling resource, bringing cultural objects and educational programming to small and isolated Sugpiaq communities that are often accessible only by seaplane. By seeing and learning about these museum objects, community members are able to bring traditional knowledge about transportation, clothing, art, and more into contemporary practice. Since Sven grew up without much knowledge about his culture, he believes that "by being able to repatriate that knowledge, put it back into a living context, we've been able to share with our future the history, the hands-on living knowledge of how our ancestors lived for the last seventy-five hundred years." His goal is to take the knowledge from restrictive, museum-only spaces into common use and sees museum work as one step in the process of taking back what colonization has taken away.

In 2007, he was awarded a MacArthur Foundation Fellowship (often referred to as the "Genius Grant"), which recognized him for his efforts in cultural and language revitalization and innovative museum practices, as well as for his work in carving, photography, and other traditional arts. He is now a faculty member at the University of Washington, where he teaches anthropology courses on ethnoarchaeology, and he is the curator of North American anthropology at the Burke Museum of Natural History and Culture in Seattle, where he continues to work to make Sugpiaq and other Indigenous cultures and history accessible to the public.

SARAH WINNEMUCCA

Northern Paiute

C. 1844–1891 • TRANSLATOR, AUTHOR,
AND PUBLIC SPEAKER

Sarah Winnemucca's life was defined by the ability to move between the world of her tribe and the non-Native world. At the time Sarah was born on her tribal homelands in what is currently known as Nevada, her tribe had limited contact with non-Natives. As white settlers encroached on their lands, Sarah eventually recognized that this change was permanent and set about using her skills to be a bridge between the communities.

Sarah's grandfather had learned English when he served as a guide for white surveyors in California, and he arranged for Sarah and her sister to live and work for a white family near Carson City, Nevada, in order to learn English and the ways of European-American culture. Once Sarah returned to her community, she served as a military translator, helping to negotiate on behalf of her community. Her commitment to look out for the best interests of her people meant that she was decidedly not a neutral interpreter. Rather than providing verbatim translations, she gave her community additional information and context, costing Sarah her job on at least one occasion. Tensions were so high because white Indian agents and government officials repeatedly lied to and exploited her people. The tribe was forced to relocate to Washington State in 1879 after the Bannock War, an armed conflict between the U.S. military and Bannock, Paiute, and Shoshone people sparked by mistreatment from the United States on the Fort Hall Reservation. So Sarah, her father, and other Paiute leaders traveled to Washington, D.C., to fight for the tribe's right to return to their reservation. They were successful, and the Secretary of the Interior said they could return—at their own expense. However, the U.S. government decided to "discontinue" their reservation, instead closing it and not allowing their people to return.

To educate the non-Native public about the injustices that Native communities like hers were facing, Sarah began giving public lectures to raise awareness and to garner support for her community. She went on to give more than three hundred lectures throughout the United States and the world. She played into the stereotype of what an "Indian Princess" should look like in order to gain people's attention and trust, only to then surprise many in the audience with her intelligence, humor, and deep knowledge. Her autobiography *Life Among the Piutes*, published in 1883, was the first book published by a Native woman. It details her life and the history of her tribe and their homelands, while offering an incisive but thoughtful critique of white colonization.

Sarah achieved international fame, broke ground as a Native woman in the public sphere, and fought hard for Native causes. She said, "I have worked for freedom, I have labored to give my race a voice in the affairs of the nation."

NICOLLE GONZALES

Diné (Navajo)

1982– • NURSE, MIDWIFE, AND
INDIGENOUS BIRTH ADVOCATE

For millennia, Indigenous communities have participated in culturally specific birthing practices that honor mothers, babies, and the community. But like many Native traditions, colonization pushed out these practices in favor of a Western, medicalized model of birth, and since hospitals are known for discriminating against Indigenous women, this model has resulted in large disparities in maternal and infant health. Thankfully, Indigenous midwives and birth workers like Nicolle Gonzales are revitalizing traditional birthing practices to give Native mothers more positive and powerful experiences.

Nicolle grew up in Farmington, New Mexico, on the border of the Navajo Nation. She obtained a bachelor's degree in nursing and a master's degree in midwifery from the University of New Mexico. Nicolle has a passion for birth work and says it is her goal "to keep birth sacred and in Native communities by integrating and applying traditional knowledge." In 2015, she founded the Changing Woman Initiative, an Indigenous women's health collective that provides traditional and holistic health care. Changing Woman Initiative is named for one of the powerful female Diné deities, who is said to have created humans and who represents balance, beauty, and power.

In 2016, Nicolle and other Indigenous midwives and birth workers traveled to Standing Rock during the resistance movement against the Dakota Access Pipeline to provide culturally grounded care to women at the Oceti Sakowin resistance camp. In August 2016, a baby was born in the camp, a little girl named Mni Wiconi (Water Is Life). Her mother gave birth to her in a tipi, with traditional birthing practices and without complication, showing the impact and importance of the work Nicolle and others are doing. To Nicolle, these traditional birthing practices are about healthy mothers and babies, but also about strengthening connections to community and ancestors. "Indigenous midwifery encompasses history and connecting with ancestors through the use of plant medicine and traditional knowledge from the community, just as their ancestors would. When Native women have that kind of support, they have a deeper connection to their bodies, to their babies, to the land, and to their communities. That deeper connection encourages healthier decisions that result in better relationships."

CURRENT ISSUES IN INDIAN COUNTRY

Throughout the colonial history of what is currently known as the United States, Native nations have faced seemingly insurmountable challenges, yet they have always persevered. Below are just a few of the current issues of focus throughout Native communities and nations. Many of these are connected and interconnected, and there are many more. By fighting for these causes, Native people are pushing to see how we can not only survive but also resist and *thrive* into the future.

WATER, LAND, AND CLIMATE CHANGE

The protection of Indigenous lands and waters, and the knowledge connected to them, is of utmost importance for moving into the future. Climate change is already hitting Indigenous communities at a much faster rate than others— without land and water, how will communities survive?

MISSING AND MURDERED INDIGENOUS WOMEN

Native women face rates of violence far above any other racial or ethnic group, and there is a current epidemic of unsolved cases of missing and murdered Indigenous women and girls in the United States and Canada. The numbers are hard to come by because of the way data are collected, but the cases number well into the thousands.

SACRED SITES

For many Indigenous people, spirituality and cultural practices are deeply tied to specific sites and places on the land, and when these places are threatened—due to construction, outdoor recreation, mining, or other causes—it is a direct threat to Indigenous lifeways. Examples of such places include Bears Ears in Utah, Chaco Canyon in New Mexico, Mauna Kea in Hawai'i, the Black Hills in South Dakota, Bear Lodge Mountains in Wyoming, and Mount Shasta in California.

RECOGNITION

There are hundreds of tribal nations in the United States who were "terminated" by the federal government during the 1950s, declared "extinct," or never formally "recognized." Federal recognition is a long and arduous process, but tribal nations cannot access treaty rights or resources promised by the U.S. government unless they have been recognized, so tribes continue to fight for their recognition.

PIPELINES, MINES, AND EXTRACTIVE INDUSTRIES

Large pipeline resistance fights against the Dakota Access Pipeline and the Keystone XL pipeline have made national news in the last few years, but there are many other pipelines, mines, and other extractive industry projects that Native communities continue to oppose. Even those projects that have been shut down have left environmental and health crises in their wake.

FOOD SOVEREIGNTY

Many reservation communities lack access to grocery stores and fresh food, so there is a growing movement among Native people to grow and harvest traditional foods, including vegetables, grains, wild medicines, and game. A new generation of Native chefs, farmers, seed keepers, and community organizers are changing the meaning of what it means to eat "local" in Indian Country.

LANGUAGE REVITALIZATION

Because of colonization, forced assimilation through U.S. government–run boarding schools, and English-only policies, many Indigenous languages are being threatened. Through the incredible work of elders, teachers, linguists, immersion schools, online courses, smartphone apps, dictionaries, and other resources, Native nations are working to revitalize Indigenous languages, not just to "save" them but also to create communities where our languages can flourish.

NICK HANSON

Inupiaq

1988– • ATHLETE

Nick Hanson is best known for appearing on *American Ninja Warrior*, a TV show where challengers compete to complete an obstacle course full of seemingly insurmountable physical challenges. He captured the hearts of audiences everywhere and used the platform to showcase traditional Alaska Native games and skills he had learned through his involvement with the annual Native Youth Olympics (NYO). Originally, these games and competitions were designed to maintain strength, endurance, and other survival skills as well as to counteract boredom during the long Arctic winters.

Nick was born in the town of Unalakleet, Alaska. Growing up, he witnessed a lot of struggle in his small town of 750 people, but he found purpose and direction in the physical challenges of the NYO. He applied to be on *American Ninja Warrior* on a whim, submitting videos of his NYO appearances, and was thrilled to be accepted. Since his debut in 2015, he has made many additional appearances on the show and become a fan favorite. After his first season on the show, he returned home to Unalakleet to work as a teacher's aide and coach of numerous sports, including NYO. He said, "It was the best feeling to show kids what I do. . . . This is what I want to do for the rest of my life."

When he was invited for a second season on the show and wasn't able to attend for financial reasons, GCI, a large telecom company in Alaska, stepped in and offered him a sponsorship, which allowed him to compete for three additional seasons. As part of this sponsorship, he travels throughout Alaska, speaking to students in schools and encouraging them to be active and involved in their communities. Working with youth and helping them understand their identity as young Alaska Natives is important to Nick. He says, "I want kids to know who they are . . . whether I'm still competing, coaching, or possibly becoming a teacher one day, I will always find a way to connect with kids. It's just the work I've been called to do."

JAMIE OKUMA

Luiseño, Shoshone-Bannock

1977– • ARTIST, BEADWORKER, AND FASHION DESIGNER

A pair of Jamie Okuma's beaded knee-high boots resides in the permanent collection of the Peabody Essex Museum in Salem, Massachusetts. These boots, covered in thousands and thousands of hand-tacked glass beads, showcase Jamie's signature colors and styles—swooping swallows, gorgeous florals, and a sky blue cut-bead background that sparkles with the light. Jamie lived in Los Angeles as a child before moving to the La Jolla Reservation with her family, where she still lives today. As a master artist and independent fashion designer, her primary medium is beadwork, but she also uses quillwork, leatherwork, and other mediums to create stunning couture fashion pieces and art. The breadth and diversity of her work are hard to capture, and her styles and techniques continue to evolve and grow.

Jamie learned to bead at age five, figuring out the techniques completely on her own by studying her mother's beadwork projects. She started out primarily making regalia for powwows, then clothes for miniature dolls, before moving into more high-fashion clothing and beadwork, and she now also makes ready-to-wear designs and jewelry. Her beaded work includes interpretations of photographs, many from popular culture and themes that wouldn't be considered "traditional" for Native art, like scenes from horror films. Much of her work has deeper meaning and reflects themes of her own life behind the chosen designs, such as her "No Place Like Home, Hōlyulkum," ruby red beaded boots that honor Jamie's homelands and her clan. The boots were inspired by Dorothy's ruby slippers from *The Wizard of Oz* that were one of Jamie's first fashion memories: "It was the color, the way they sparkled, and the magic ability to take you home no matter where you were. I was a fish, they were my bait, and I was hooked."

Jamie cares about using the best materials available for her work, saying, "Detail and quality are the two elements I obsess about most." She primarily works with Italian leather; antique French, Italian, and Czech seed beads; and, whenever possible, in her beaded pieces she uses Native brain-tanned buckskin from her grandmother's reservation. Jamie is protective over Native art and designs and often speaks out against cultural appropriation and the misuse of Native designs and cultural elements. She wants everyone to enjoy and wear her work and says, "The person who wears my pieces is a lover of life, culture, and diversity. They are unafraid to make a statement and be noticed."

NAINOA THOMPSON

Kanaka Maoli

1953– • NAVIGATOR

Nainoa Thompson is a Kanaka Maoli navigator, known for preserving Polynesian navigation practices. As a child, Nainoa struggled to be engaged in school, preferring to be near the ocean, and in 1974, he found his purpose and passion when he met a team of other Native Hawaiians who were working to revitalize traditional Hawaiian voyaging. Hawaiian oral histories relate stories of their Polynesian ancestors traveling the Pacific on large double-hulled canoes, navigating by the stars and by other environmental means, but Western science has dismissed these stories as only myths, claiming that the Hawaiian Islands were populated purely by chance due to winds and currents. The group Nainoa met was designing a traditional canoe, with the goal of sailing it over twenty-five hundred miles to Tahiti without modern instruments. They named it *Hōkūle'a* after the North Star.

Nainoa joined the crew of the *Hōkūle'a* and began learning about traditional navigation techniques; he was trained by famed Micronesian navigator Mau Piailug. In 1976, Mau navigated *Hōkūle'a*'s first voyage to Tahiti. Successfully sailing such a distance without Western tools was a major accomplishment, demonstrating to the world and the Hawaiian people what was possible and proving that the stories of their ancestors were true. When the canoe came ashore in Tahiti, it was met by seventeen thousand people, including Nainoa. In 1980, after this successful initial voyage, the goal became to sail again with Hawaiians at the helm. After decades of work from the *Hōkūle'a* team through scientific study and hands-on learning with the help of Mau, *Hōkūle'a* made another journey to Tahiti, navigated by Nainoa and a crew of Hawaiians, ushering in a new era of Hawaiian voyaging. Since then, the canoe has traveled all over the Pacific, including all the way to Aotearoa (New Zealand), and new crews of navigators are being brought in and trained all the time.

Nainoa is now president of the Polynesian Voyaging Society, and from 2014 to 2017, he participated in the Mālama Honua Worldwide Voyage and sailed *Hōkūle'a* and her sister canoe to visit thirteen UNESCO World Heritage marine sites. Nainoa continues to cross the globe in *Hōkūle'a* and to teach traditional navigation practices to the next generation, saying, "Our people and those who come here should know the richness of our heritage. And not only know that but respect it. If we're to protect what we believe is special about our islands, we have to educate our people as to why it's special. These canoes are just a mere fraction of what's valuable in these islands. And I just am very glad to be a part of that . . . and our islands."

WILMA MANKILLER

Cherokee

1945–2010 • PRINCIPAL CHIEF AND COMMUNITY ORGANIZER

Women have always been central and important to Cherokee people. Cherokees are matrilineal, which means that clan membership is passed from mother to child, that women were the traditional holders of property and land, and that women have always held significant spiritual and cultural leadership positions within Cherokee society. Despite these traditional understandings, the modern Cherokee Nation had never had a woman in the role of Principal Chief until Wilma Mankiller stepped into the role in 1985.

Wilma was born in Tahlequah, Oklahoma, but during the period of federal relocation in the 1960s, she and her family moved to San Francisco, California. The Mankillers, like thousands of other Native families, were promised jobs, housing, and opportunities if they left their reservations and homelands and moved to urban centers. The architects of this policy saw it as a method of assimilation, thinking that if Native people moved into cities, they would abandon their Native ways and become "mainstream" Americans.

Instead, Native folks found each other in these cities, and created a sense of home and identity in these new places, while still maintaining their bonds with their home nations. Wilma grew up in urban poverty and faced immense discrimination, but was also surrounded by a diverse Indigenous activist community. She credits her time in these activist communities, learning alongside leaders like labor activist Dolores Huerta and being involved in the 1969 occupation of Alcatraz island with shaping her belief that Native communities should support and govern themselves.

In 1977, she moved back to Oklahoma with her children and began advocating for the needs of rural Cherokees. She embodied the Cherokee concept of gadugi, or collective community work toward a common goal. Despite her relatively recent return to the Oklahoma community, Ross Swimmer chose Wilma as his running mate in the 1983 Cherokee Nation election, and they won. In 1985, Swimmer was tapped for a role in the federal government, and Wilma took over as Principal Chief. She won two more terms as Principal Chief before deciding not to run for reelection in 1995 because of poor health. As a leader, she observed the interconnectedness of economic growth and social programs and put the revenue from casinos and other tribal businesses back into health clinics, job training programs, and other community initiatives. During her time as Principal Chief, tribal enrollment grew, infant mortality dropped, and employment rates doubled.

Wilma believed in fighting for community, saying, "The most fulfilled people are the ones who get up every morning and stand for something larger than themselves. They are the people who care about others, who will extend a helping hand to someone in need or will speak up about an injustice when they see it." After battling many personal tragedies and health hardships throughout her life, she died from cancer in 2010, leaving a legacy of leadership and cultural pride.

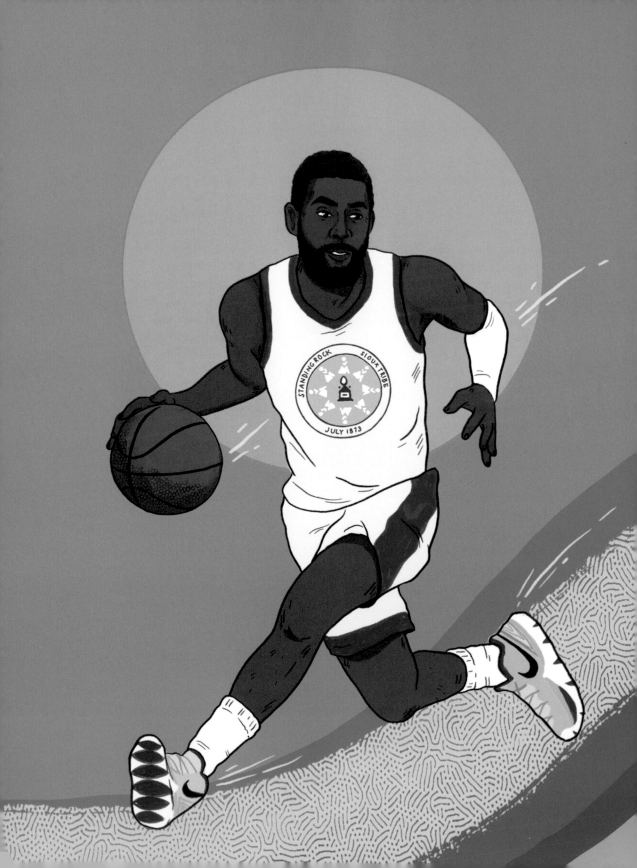

KYRIE IRVING

Standing Rock Lakota

1992– • PROFESSIONAL BASKETBALL PLAYER

Kyrie Irving is well known for his skill on the basketball court. He was the number one National Basketball Association (NBA) draft pick in 2011, was named Rookie of the Year while playing for the Cleveland Cavaliers, and has played for the Boston Celtics and the Brooklyn Nets.

He also has an inspiring story of reconnection with his Lakota family. He was born in Melbourne, Australia, to American parents. His mother, Elizabeth, was Lakota, born on the Standing Rock Reservation. Unfortunately, Elizabeth was adopted out of the community during a time when Native children were being systematically removed from their communities and placed for adoption with non-Native parents. During the late 1960s, when Elizabeth was born, it is estimated that 25 to 35 percent of all Native children were removed from their families and placed in the foster system; those children were put up for adoption at rates sixteen times higher than that of non-Natives. Eventually, through the tireless work and advocacy by Native people, a law called the Indian Child Welfare Act (ICWA) was passed in 1978 to keep Native children with Native families and in Native communities. Because Elizabeth's adoption occurred prior to ICWA, she was raised outside of her nation, but she always knew where she came from.

Kyrie's mother passed away when he was four, and he was raised by his father and aunties. As Kyrie grew up and rose through the basketball ranks, with a successful high school career in New Jersey, a season for Duke University, and an NBA championship with the Cavaliers, he always remembered his Native roots. During the movement against the Dakota Access Pipeline on Standing Rock lands in 2016, Kyrie publicly voiced his support and donated money to the cause.

Then, in 2018, the tribe hosted a "welcome home" ceremony for Kyrie and his older sister. In front of a thousand tribal members, Kyrie received an eagle feather and was given the name Hela (Little Mountain), in honor of his ancestral family name of "Mountain." He says, of his ties to his nation, "I'm extremely proud to be Lakota Sioux, and at the same time, I'm still in the process of diving deeper into discovering who I am and where I come from. Everything that comes with my background is something I've always accepted, but I didn't necessarily understand it until now. The immense pride I feel comes from this journey I've been on, this rediscovery I've made in my adult life."

Kyrie's journey of reconnection shows the depth of the relationships and kinship ties throughout Native nations, and that even though colonization attempted to sever those ties, there are always pathways back home.

VI WAGHIYI

Yupik

1959– • ENVIRONMENTAL ADVOCATE

In 2002, Vi Waghiyi read about the impact of toxic chemicals called PCBs (polychlorinated biphenyls) on her Yupik community and was inspired to take action. PCBs were used in hundreds of industrial and commercial products until 1979, when they were banned because they can cause severe health problems. Vi is a self-described "Yupik grandma" from Savoonga, Alaska, on Sivuqaq (St. Lawrence Island) on the northern Bering Sea, and her community has experienced high rates of cancer and disease due to PCB exposure. She points out that there is no Yupik word for PCBs or toxic chemicals, because colonization brought in these contaminants. When Vi learned about the health crisis caused by PCBs from a ACAT press release, she got a job with the Alaska Community Action on Toxics (ACAT), an organization that provides assistance to communities battling the harms of toxics through research, advocacy, and training. "I believe the creator had a role for me to learn to use my voice to advocate for my family, our Sivuqaq people, and those who are not granted opportunities to voice the injustices disproportionately harming communities like mine," Vi said.

Through community-based research and her work with ACAT, Vi found that the residents of Sivuqaq have PCB levels 4 to 10 times higher than the average American. Their research attributes this to an accumulation of PCBs in the blubber of marine mammals like whales and seals—which are major food sources for the community—as well as from direct contamination from abandoned and buried WWII era military outposts on the island. These high levels of PCBs harm the health of her community, causing cancer and other health disparities, and there has been no adequate funding from the U.S. government in cleanup efforts or education campaigns despite its role in bringing these toxics to Alaska. Despite the dire numbers and huge challenges in educating the general public on these toxics, Vi maintains hope that someday the true impact of these chemicals on Alaska Native communities will be known and addressed, and more bans on their use will be put in place to stop further contamination. She says, "I can't see myself doing anything else as much as I've come to learn, and I never knew there was so much injustice globally. I now know I'm where I'm supposed to be and it's my calling. I still have hope because there are more good people in the world than the few driven by corporate greed and profit. This work is personal and difficult. To win this fight will take all of us."

SUZAN SHOWN HARJO

Cheyenne, Hodulgee Muscogee Creek
1945– • WRITER, CURATOR, ACTIVIST, AND EDUCATOR

In 1965, when Suzan Shown Harjo was twenty, she and her mother visited the Museum of the American Indian in New York City. They were horrified to see medicine masks, burial moccasins, and beaded pouches with baby cords intended to be kept from cradleboard to grave, as well as a Cheyenne child's buckskin dress with a bullet hole in it. At the time, there was no law or protection for either Native human remains or for sacred, ceremonial, or funeral objects. Museums could display them with impunity and there was no directive to return them to the tribes they had been taken from, often illegally. Suzan's mother tasked her with making sure that "none of these sacred living beings are left in any museums." This set Suzan on a lifelong journey of fighting for Native rights and representation in museum spaces and protecting Native religious freedom and sacred spaces, including burial grounds. With a record of leading campaigns for hundreds of laws, and for recovering more than one million acres of Native lands, there are few other people who have had such an influence on all of the most significant American Indian policies over the last forty years.

Born in El Reno, Oklahoma, Suzan spent her early life on her Muscogee family's allotment land. She moved to New York City as a young mother and started working in theater and broadcasting. In 1967, she and her husband, Frank Ray Harjo, created the first Native American issues radio show, *Seeing Red.* In 1974, Suzan moved to Washington, D.C., where she focused on policy and museum work, remembering her mother's words about those objects they had seen long ago in New York.

The impact of her activism and advocacy is immense. She worked to draft and pass the American Indian Religious Freedom Act of 1978; The National Museum of the American Indian (NMAI) Act of 1989, which established the Smithsonian NMAI; the Native American Graves Protection and Repatriation Act (NAGPRA) in 1990; and the Executive Order, Indian Sacred Sites, in 1996. Suzan served as the executive director of the National Congress of American Indians from 1984 to 1989 and has been president of the Morning Star Institute since 1984.

Since the 1960s, her work has also focused on ending the use of Native American mascots and other offensive Native imagery. In 1992, she and other activists sued the Washington Redsk*ns, seeking to revoke their trademark on the grounds that it was racist. It took until 2020 for the team to change their name, after a groundswell of public pressure, led by Suzan and other Native activists, caused multiple sponsors to cancel their sponsorship unless the racist name was changed. In 2014, President Obama awarded Suzan the Presidential Medal of Freedom for her incredible lifetime of work; in 2020, she was elected to the American Academy of Arts and Sciences. She continues to fight on behalf of Native rights and to inspire an entire generation of young Native activists to fight for their people.

MORE NOTABLE NATIVE PEOPLE

It is impossible to account for all of the Native people who have made a difference in the world, let alone to fit them in a single book. Every Indigenous life is important and notable, and our people have been leaders and changemakers for hundreds of generations. These are some more notable people you should know about, but don't let your learning end here! I encourage you to seek out more stories of Indigenous people and their lives, to deepen your understanding and appreciation of the complexity and diversity of our experiences.

ANTHONY TAMEZ-POCHEL 2000–

A Chicago-based Cree, Lakota, and Black activist for Native mascot changes and other representation issues, as well as co-president of Chi-Nations Youth Council, an urban youth group.

MARITA GROWING THUNDER 1999–

A Fort Peck and Kiowa activist and organizer for the cause of Missing and Murdered Indigenous Women and Girls (MMIWG) and the leader of the Save Our Sisters project, which raises awareness and advocates for policy changes to address the issues of MMIWG.

NAMPEYO 1859–1942

A Hopi and Tewa Pueblo potter, who created the Hopi revival–style pottery, which used designs and techniques from fifteenth-century Pueblo potsherds. Her work was world renowned and is held in museum collections worldwide. In 2010, one of her pots sold for $350,000.

LOUISE ERDRICH 1954–

An award-winning Turtle Mountain Anishinaabe author of over thirty works, including novels, poetry, nonfiction, and children's books. Her books tell the stories of multi-dimensional Anishinaabe characters, bringing true Native portrayals and perspectives into literature.

RADMILLA CODY 1975–

The first Black Diné person to win the title of Miss Navajo, which is a competition that includes language fluency, sheep butchering, and other traditional skills. She is also an accomplished singer, public speaker, activist, and advocate for Black Diné people.

MARY GOLDA ROSS 1908–2008

The first known female Native engineer and the first female engineer to work at the aerospace company Lockheed. A Cherokee citizen originally from Oklahoma, she helped design early plans for interplanetary travel.

QUANNAH CHASINGHORSE POTTS 2003–

A Han Gwich'in and Oglala Lakota environmental activist and one of the leaders in the fight for Alaska Native communities affected by climate change.

JOY HARJO 1951–

An award-winning Muscogee Creek author, the twenty-third Poet Laureate of the United States, and the first Native poet laureate. She has written many poetry collections and children's books as well as plays and a memoir; she is also an accomplished saxophone player.

PETER KAISER 1987–

A Yup'ik dog musher, who won the 2019 Iditarod Trail Sled Dog Race in Alaska. He was the first Yup'ik winner and the fifth Alaska Native winner of the race since its founding in 1973.

WALTER RITTE 1945–

A leader in Hawaiian activism efforts focused on opposing land development, the protection of water rights and sacred land such as Mauna Kea, and the labeling of GMOs. He was one of the Kahoʻolawe Nine, the group of Kanaka Maoli activists who were imprisoned for occupying the island of Kahoʻolawe for thirty-five days in 1976 in an attempt to reclaim the land from U.S. Navy occupation and bombing.

PRINCESS RED WING 1896–1987

Born Mary Congden, a Narragansett and Wampanoag sachem, historian, storyteller, and culture keeper. She designed the Narragansett tribal seal and helped draft the first tribal bylaws in 1934. She also co-founded the Tomaquag Museum, one of the oldest tribal museums in the country, and dedicated her life to preserving and sharing Narragansett culture and history.

GEORGE HELM 1950–1977

A leader of the Aloha ʻĀina movement and member of the Kahoʻolawe Nine, who fought for Kanaka Maoli land rights, to protect Hawaiian homelands, and to take back Kahoʻolawe from U.S. military occupation and bombing. Tragically, he disappeared in 1977 attempting to reach Kahoʻolawe in harsh conditions.

MONIQUE MOJICA 1954–

A Kuna and Rappahannock playwright and actress, who was a founding member of Native Earth Performing Arts and is the artistic director of the Chocolate Woman Collective. She wrote *Princess Pocahontas and the Blue Spots*, a satirical play about colonization and the power of women.

KIM SMITH 1984–

A Diné activist, writer, curator, citizen scientist, and the co-founder of *Indigenous Goddess Gang*, an online magazine for Indigenous femmes that examines the issues of Indigenous communities through an Indigenous feminist lens.

LOUIE GONG 1974–

A Nooksack entrepreneur, designer, artist, and the founder of Eighth Generation, a lifestyle design company that sells beautiful home goods, including wool honor blankets, designed to celebrate Native artists and to provide a Native-made alternative to exploitative non-Native companies.

Acknowledgments

As with everything I do as a Cherokee person, this book was completed through my web of relationships, and I could not have done it alone. Wado (thank you) with all my heart to my amazing editor, Kaitlin Ketchum, and the many people at Ten Speed Press—Lizzie Allen, Kimmy Tejasindhu, Want Chyi, and Serena Sigona—who assisted with all levels of the project; my agent, Alia Hanna Habib; Ciara Sana for her incredible art and her deep care with her work; and my amazing research assistants Isabella Robbins, Raelee Fourkiller, and Anne Fosberg.

Wado to all of the folks who nominated and suggested individuals for the book, including Kelly O'Brien and Breylan Martin, who helped with Alaska; Makana Kushi and Jamaica Osorio, who helped with Hawai'i; my Instagram family and community who provided so many names; and *Indigenous Goddess Gang*'s archive of "Matriarch Mondays" and "Woman Crush Wednesdays" that gave me ideas and directed me to historic women. Wado to my writing and life support crew: Eve Ewing, Elena Shih, Elizabeth Hoover, Monica Ng, Mikaela Crank, Amanda Tachine, Tim San Pedro, Clint Smith, Christina Villarreal, Jennifer Weston, Matika Wilbur, Teo Shantz, and Kira Keenan. Also wado to the untz team: Annie Ta, Lakshmi Alagappan, Megan Stacy, Charlotte Helvestine, Elena Griego, Carling Nguyen, Jenny Zhao, Kate Hanlon, and Alicia Dennis. Of course, wado to my forever supportive parents, Jim and Pat Keene; my sister, Michele Keene; my chiweenie, Mochi Nuna; and all of my ancestors who fought so hard for me to be here. I also want to acknowledge and thank all of the leaders, dreamers, and changemakers included in the book for their inspiring work and lives, as well as the thousands and thousands more who didn't make it into these pages but could have: You've shown me that the Indigenous past, present, and future are beautiful and bright.

About the Author

ADRIENNE KEENE is a citizen of the Cherokee Nation and originally from Southern California. She is a scholar, writer, and podcaster whose work focuses on representations of Native people in popular culture, as well as Indigenous students in higher education. She is the longtime author and editor of *Native Appropriations*, a blog about cultural appropriation, and the co-founder and co-host of the podcast *All My Relation*s, which examines Indigenous relationships and asks how we can be good relatives to one another, the land, and our nonhuman relations. You can find her online at nativeappropriations. com or adriennekeene.com, or on social media @NativeApprops.

About the Illustrator

CIARA SANA is a Chamoru artist currently based in Bellingham, Washington, but grew up in Guam, where she was surrounded by a mix of Indigenous Chamoru culture and people from all over the Pacific islands, Asia, and the U.S. mainland. Ciara's art is deeply rooted in her culture and inspired by all the different styles and flavors found on the beautiful island. The goal of her work is to empower and uplift others, celebrate differences, and encourage love. You can find her online at artbyciara.com and on Instagram @artbyciara.

Index

Library of Congress Cataloging-in-Publication Data
 Names: Keene, Adrienne, 1985- author.
 Title: Notable native people : 50 indigenous leaders, dreamers, and
 changemakers from past and present / Adrienne Keene.
 Description: First edition. | Emeryville : Ten Speed Press, [2021]. |
 Includes index.
 Identifiers: LCCN 2021003418 (print) | LCCN 2021003419 (ebook) | ISBN
 9781984857941 (hardcover) | ISBN 9781984857958 (ebook)
 Subjects: LCSH: Indians of North America—Biography—Juvenile literature. |
 Hawaiians—Biography—Juvenile literature.
 Classification: LCC E89 .K44 2021 (print) | LCC E89 (ebook) | DDC
 920.0092/97—dc23
 LC record available at https://lccn.loc.gov/2021003418
 LC ebook record available at https://lccn.loc.gov/2021003419]

Hardcover ISBN: 978-1-9848-5794-1
eBook ISBN: 978-1-9848-5795-8

Printed in China

Editor: Kaitlin Ketchum
Production editor: Kimmy Tejasindhu
Editorial assistant: Want Chyi
Designer: Lizzie Allen
Production designers: Mari Gill and Howie Severson
Production manager: Serena Sigona
Copyeditor: Dolores York
Proofreader: Kate Bolen
Indexer: Ken DellaPenta
Publicist: Felix Cruz
Marketer: Monica Stanton

10 9 8 7 6 5 4

First Edition